DIY PAPERCRAFTS

Marisa Edghill

This library edition published in 2017 by Walter Foster Jr.,
an imprint of The Quarto Group
6 Orchard Road, Suite 100
Lake Forest, CA 92630

Artwork and photographs © 2016 Marisa Edghill.
Acquiring Project Editor: Stephanie Carbajal
Page Layout: Krista Joy Johnson

Distributed in the United States and Canada by
Lerner Publisher Services
241 First Avenue North
Minneapolis, MN 55401 U.S.A.
www.lernerbooks.com

First Library Edition

Library of Congress Cataloging-in-Publication Data

Names: Edghill, Marisa, author.
Title: DIY papercrafts / Marisa Edghill.
Description: First library edition. | Lake Forest, CA : Walter Foster Jr., an
 imprint of Quarto Publishing Group USA Inc., 2017.
Identifiers: LCCN 2017011552 | ISBN 9781942875277 (hardcover)
Subjects: LCSH: Paper work. | Tape craft. | Gummed paper tape. | Japanese
 paper.
Classification: LCC TT870 .E33 2017 | DDC 745.54--dc23
LC record available at https://lccn.loc.gov/2017011552

Printed in USA
9 8 7 6 5 4 3 2 1

DIY PAPERCRAFTS

CUT, TAPE, AND FOLD
your way through tons of
creative & colorful
papercraft projects & ideas

TABLE OF CONTENTS

Introduction

Make .. 12

Wrap ..42

Draw .. 68

Mix.....................................92

Write.........................114

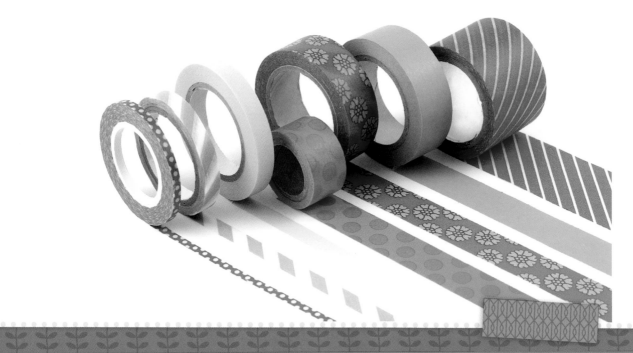

Introduction

* * * * * * * * * * * *

Getting to Know Washi Tape

Originally from Japan, washi tape can now be found just about everywhere and in almost any color or design imaginable. These pretty tapes are now available at art and craft stores, specialty stores, and even dollar stores. But why is this tape so popular? What makes it special? And what on earth are you supposed to do with it?

What is Washi Tape?

Washi tape is a prettier version of masking tape designed for art and craft purposes. True washi tape is always made out of paper (never plastic), is more delicate than standard masking tape, is often translucent (but never transparent), and uses a low-tack adhesive. Washi tape is easy to tear and cut, can be written on, and is removable and repositional on most surfaces without damaging the tape or the surface. Not to be confused with paper tapes, washi tape uses delicate Japanese-style paper as a base. High-quality washi tapes are also acid-free, lignin-free, and in rare cases, food-safe.

Why Washi Tape?

Washi tape is the ultimate multitasker! Use it to stick pictures on your bedroom wall, seal a package in the kitchen, decorate outgoing mail, or even to dress up old furniture. The tapes are pretty but strong, and the low-tack adhesive makes them easy to use, no matter your skill level. This combo of great design with an abundance of stress-free uses has made these tapes popular with people, crafty or not, all over the world.

Building Your Washi Tape Collection

There are so many different tape designs and brands, and it can be overwhelming. I think a great collection includes a mix of solids and patterns in a variety of widths, plus a few special designs that you really love. While special designs and die-cut tapes are more fun than the basics, they tend to be less flexible for art and craft purposes.

Using Washi Tape

The easiest way to use washi tape is to simply tear a strip and stick it to the desired surface. But there are many other ways to use this material for both decorative and functional purposes. Through the projects in this book, you'll discover a variety of techniques that will help you unlock the full potential of your tape collection.

Picking a Backing Paper

Whether you're making a large shape out of multiple tape strips or cutting tiny details out of a small piece, backing paper makes things easier. Choose a paper that tape peels easily off of, such as parchment paper and wax paper (use the unwaxed side). My favorite kind is the shiny backing paper from shipping labels.

Punching Sticker Shapes

Punching stickers out of washi tape can be tricky. To avoid frustration, first apply tape to a piece of backing paper. If you're using multiple strips of tape, make sure each piece of tape slightly overlaps the one placed before it. Put a piece of card stock behind the tape-covered backing paper. Using the paper punch, punch upward through the card stock to create your sticker. To use the sticker, simply peel off the paper backing.

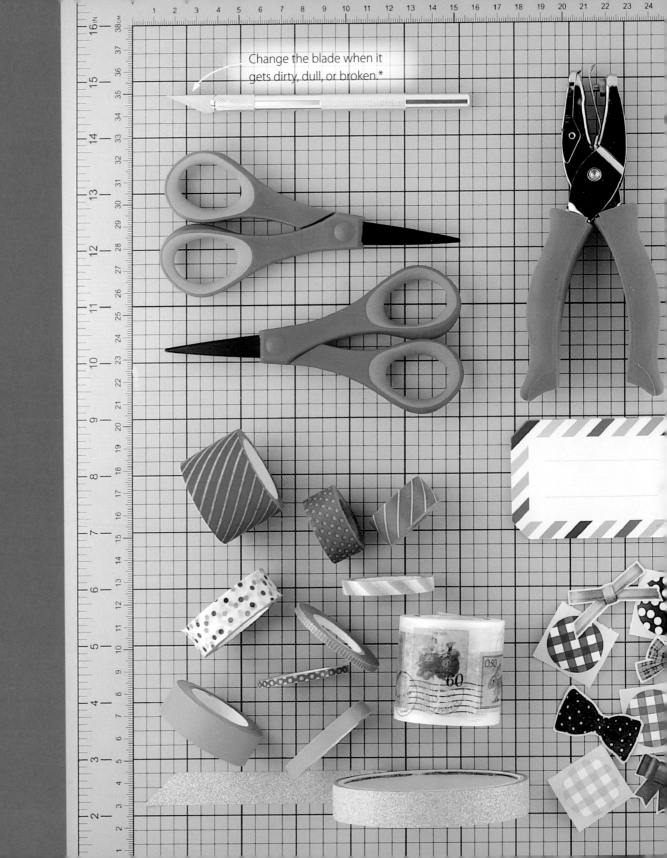

Change the blade when it gets dirty, dull, or broken.*

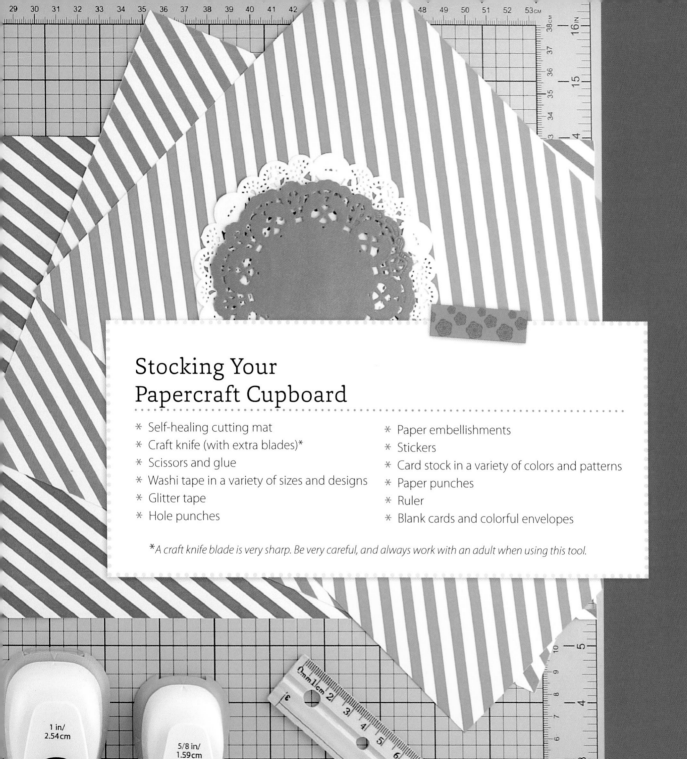

Stocking Your Papercraft Cupboard

* Self-healing cutting mat
* Craft knife (with extra blades)*
* Scissors and glue
* Washi tape in a variety of sizes and designs
* Glitter tape
* Hole punches
* Paper embellishments
* Stickers
* Card stock in a variety of colors and patterns
* Paper punches
* Ruler
* Blank cards and colorful envelopes

A craft knife blade is very sharp. Be very careful, and always work with an adult when using this tool.

1 in/ 2.54 cm

5/8 in/ 1.59 cm

5 WAYS TO USE PAPER DOILIES

✳ ✳ ✳ ✳ ✳ ✳ ✳ ✳ ✳ ✳ ✳ ✳ ✳ ✳ ✳ ✳ ✳ ✳ ✳

Doilies might have a reputation for being old fashioned, but these lacy lovelies are actually a perfect addition to your craft cupboard. While white is classic, look for brightly colored ones too. From pretty mail to gorgeous gift wrap, there are so many ways to use them. Here are just five ways.

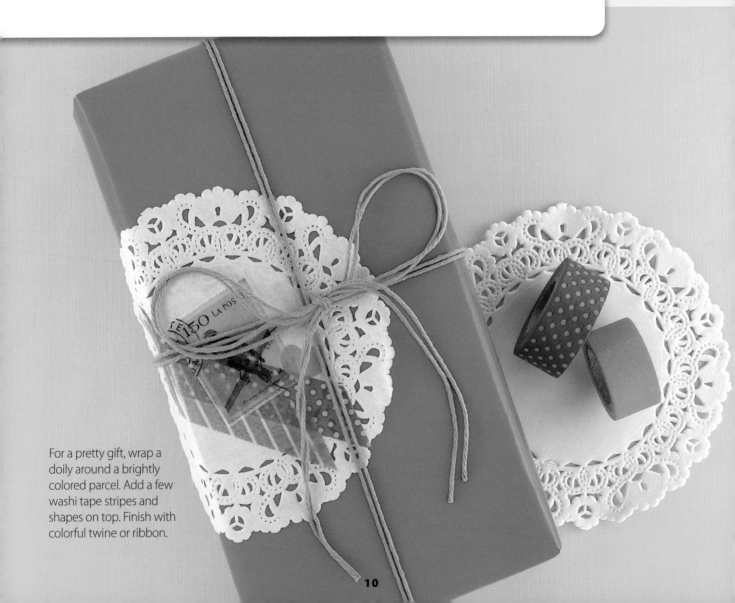

For a pretty gift, wrap a doily around a brightly colored parcel. Add a few washi tape stripes and shapes on top. Finish with colorful twine or ribbon.

Add a bit of delicate charm to an envelope by folding and gluing a doily around one edge. Don't forget a few bright strips of washi tape too.

Skip the card and write your message on a doily! Add a wee washi tape heart for extra sweetness.

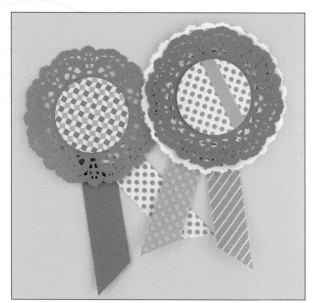

Paper doilies make the prettiest rosettes to use as gift toppers or name tags. Combine a doily or two with washi tape-covered card stock shapes to form the classic prize-ribbon shape.

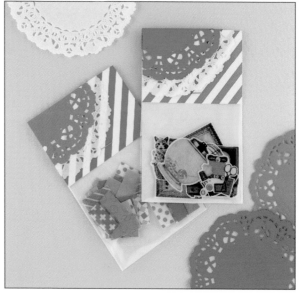

Elevate simple clear bags with layered doilies on patterned card-stock headers. These cuties are perfect for packaging stickers or small sweet treats.

MAKE

Simple materials can
have a great impact when
used together. Combine
washi tape and paper
to make pretty mail,
adorable puppets, hand-
woven baskets, and lovely
accessories.

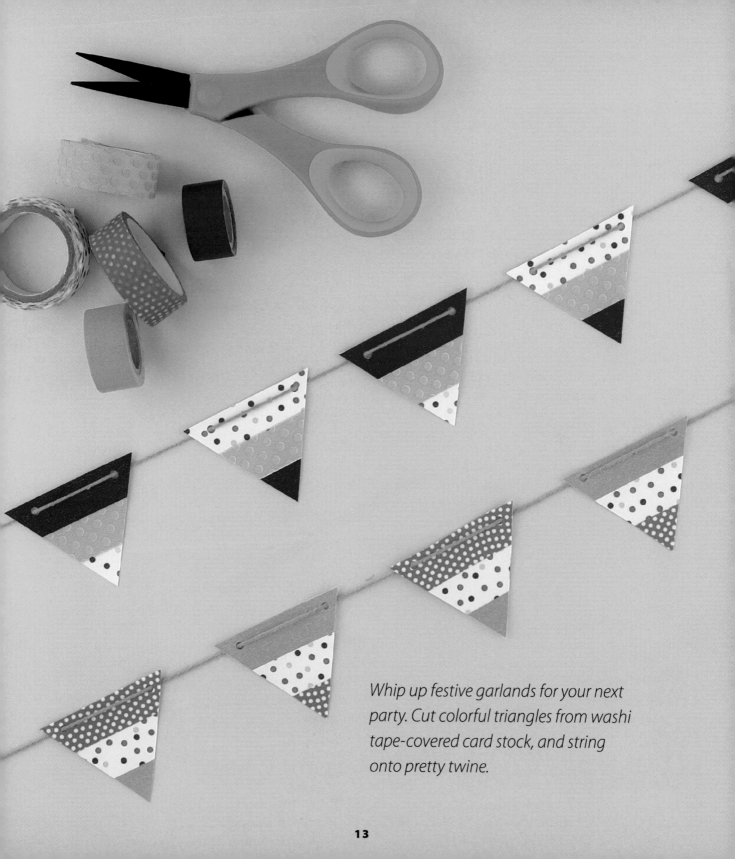

Whip up festive garlands for your next party. Cut colorful triangles from washi tape-covered card stock, and string onto pretty twine.

AEROGRAMMES

In the era of e-mail, there is nothing better than discovering pretty mail in your mailbox. Make someone's day by sending a clever handcrafted letter. Inspired by classic fold-and-mail aerogrammes, this project combines a letter and envelope into one pretty package. It's as simple as cut, fold, write, and stick!

TOOLS & MATERIALS

- Card stock or scrapbook paper
- Bone folder
- Ruler or straight edge
- Lined paper (optional)
- Glue (optional)
- Washi tape
- Scissors
- Pencil

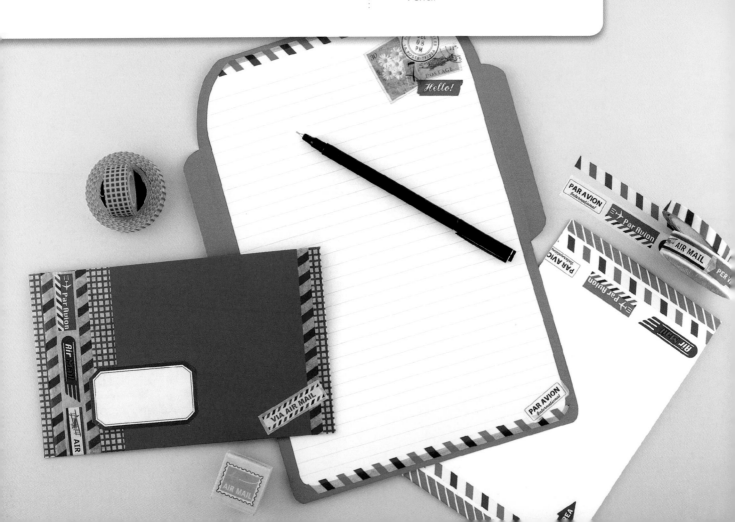

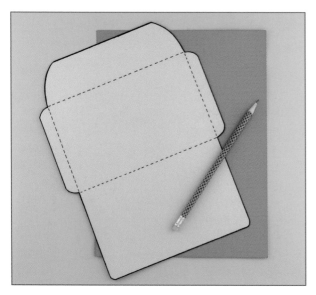

STEP 1

Trace an aerogramme shape as shown onto a piece of card stock or scrapbook paper.

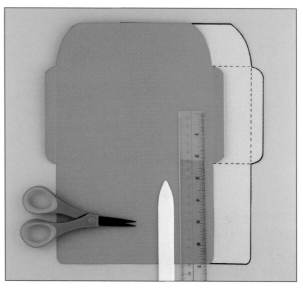

STEP 2

Cut out the aerogramme shape. Use a bone folder and a ruler or other straight edge to score and fold along the dotted lines marked on the template.

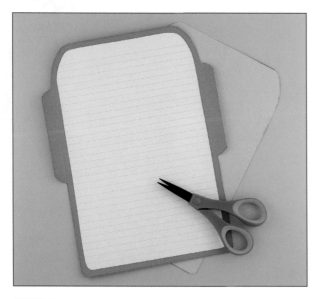

STEP 3

If desired, create a liner for the card. Glue the liner to the inside of the aerogramme.

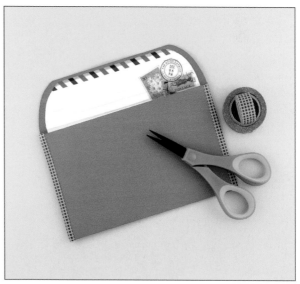

STEP 4

Write your letter on the inside of the aerogramme. Then fold the side flaps in and the bottom edge up. Secure the sides with washi tape.

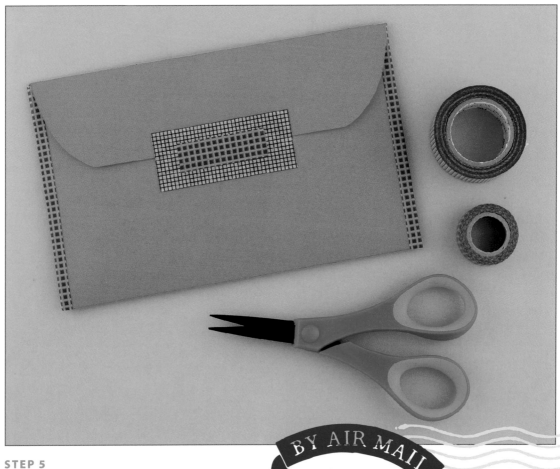

STEP 5
Seal the back flap with more tape.

TIP
When making envelopes, you can skip the washi tape and simply glue the sides and flaps down for mailing.

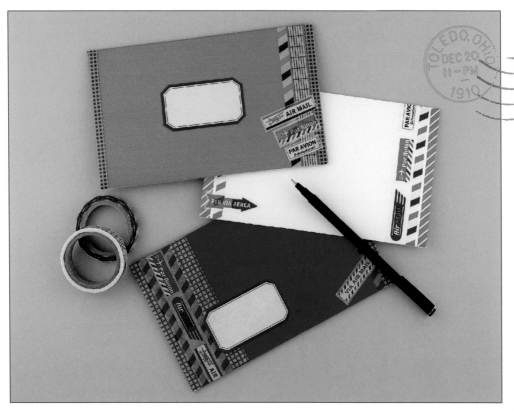

STEP 6

Decorate the exterior of the aerogramme with washi tape strips, stickers, or stamps. Don't forget to leave space for the address!

MAKE IT AN ENVELOPE!

The aerogramme shape can also be used to make envelopes! Use pretty scrapbook papers, or try upcycling magazine or catalog pages.

WOVEN WASHI BASKETS

✳ ✳ ✳ ✳ ✳ ✳ ✳ ✳ ✳ ✳ ✳ ✳ ✳ ✳ ✳ ✳ ✳ ✳

Weave colorful containers to hold your desktop supplies, and put your favorite washi tapes on display. Inspired by classic square baskets, this project uses a unique construction technique that results in crisp square edges. These containers look just as pretty with a combination of patterns as they do in solid colors, as shown here.

TOOLS & MATERIALS

- White or cream card stock (8$\frac{1}{2}$" x 11")
- Washi tape (standard $\frac{5}{8}$" wide)
- Scissors
- Ruler
- Pencil
- Bone folder
- Glue

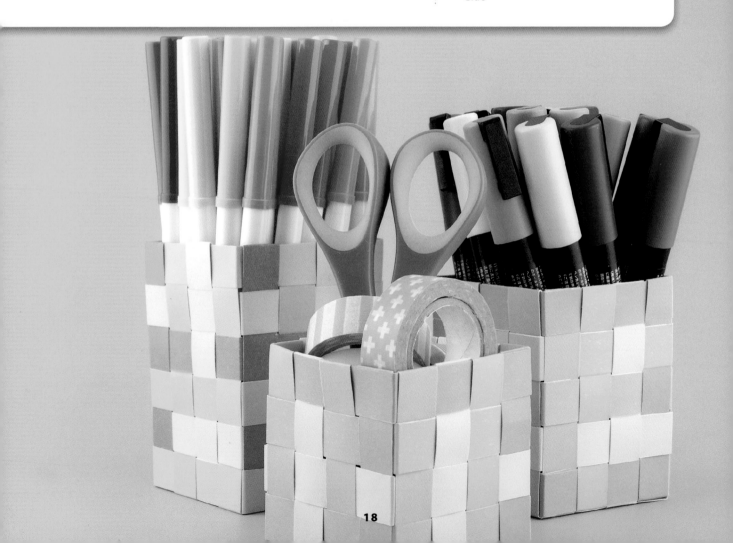

18

STEP 1

Apply strips of washi tape along the length of a piece of white or cream card stock, and cut out the strips. You will need approximately 12 to 16 strips for each container.

STEP 2

Choose eight strips for the base of the container. Place one strip facedown in front of you. Lay the ruler on top, aligning the left edge of the strip with the zero point on the ruler. Make a small mark at the 4¼" and 6¾" points. Using the bone folder, score and fold the strip at these two points. Repeat with the other seven strips. Set aside.

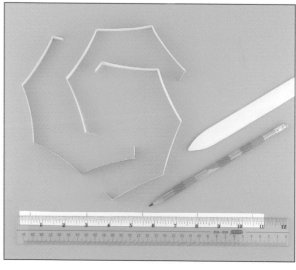

STEP 3

On the back of the remaining strips, make a small mark at the ½", 3", 5½" , 8", and 10½" points. Using the bone folder, score and fold the strips at each of these points.

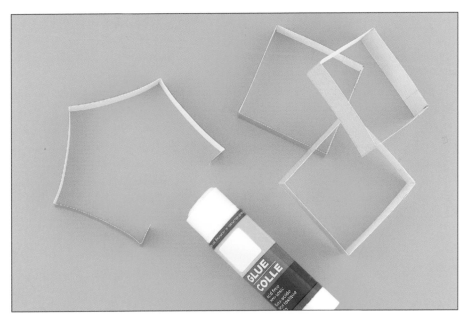

STEP 4

Fold each of the strips from step 3 into a square. Overlap the extra ½" piece at each end and glue into place. Set aside.

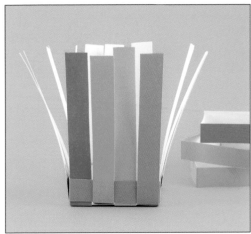

STEP 5

Next form the base of the container, using the original eight strips. Lay four strips horizontally. Weave in the other four strips vertically, using an over/under basket-weave pattern. Gently push the strips together to eliminate spaces between them.

STEP 6

Flip base over, and fold up every other strip. Slide the first square strip (from step 4) over the vertical strips and onto the base. Fold up the other base strips so that they overlap the square. Make sure that the glued end of the square is hidden behind one of the overlapping vertical strips.

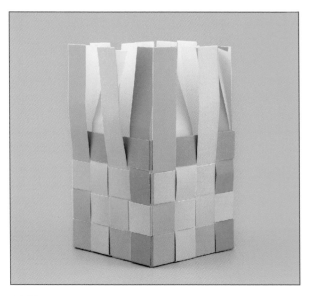

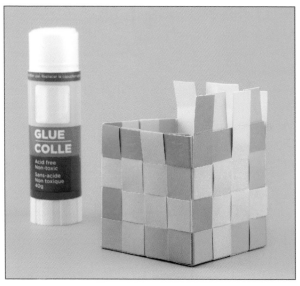

STEP 7

Continue adding the squares. Alternate the vertical strips in a basket-weave pattern until the container is as high as you like. When all the strips are in place, gently tug each vertical strip upward to tighten it.

STEP 8

Starting with the bottommost square, carefully push each square strip down toward the base to eliminate extra spaces. Cut the vertical strips approximately ½" above the top of the container. Fold the outer vertical strips over the top and glue into position inside the container. Fold the inner vertical strips over the top of the container to crease, and then glue into position on the inside. Let the glue dry thoroughly before using.

MAKE IT A FAVOR!

Want to add some cute washi flavor to your springtime table? Transform your container into a basket with a simple handle. Tape a strip of washi-tape-covered card stock to the inside of the basket. For added strength, staple the handle on each side of the basket. Fill with shredded paper and candy or small toys. For an extra-special touch, add handwritten name cards, and use as decorative place settings.

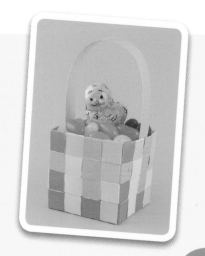

SHOOTING STARS

* *

Craft a galaxy of pretty paper stars using your favorite shades of washi tape. These stars are simply satisfying to create all on their own, but you can also use them as decorations, gift toppers, and ornaments. Keep it simple with a single star, or string together a whole constellation! Prefer to make your stars out of pretty paper? You can fold these paper stars out of any paper you please by using a ratio of 1:12.

TOOLS & MATERIALS

- Paper (8$\frac{1}{2}$" x 11")
- Washi tape
- Glitter tape (thin masking-tape style)
- Scissors
- Glue
- Small hole punch
- Twine or ribbon

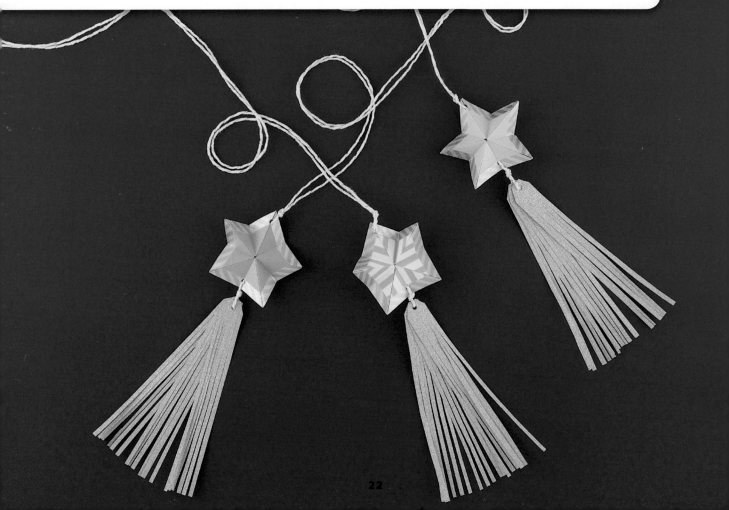

TIP
Standard printer or copy paper is perfect for this project. For easy folding, thin paper works best because the tape adds extra bulk.

STEP 1
Apply one strip of standard-width (⅝") washi tape along the length of the paper. Apply a second slim-width (¼") strip of washi tape next to it so that the two strips of tape are aligned without gaps or overlapping. Cut out the strip. Repeat for as many stars as you wish to make.

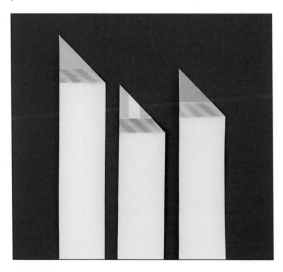

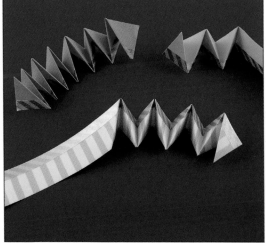

STEP 2
Starting at one end, with the tape-covered side facing down, fold the top right corner down to meet the left edge of the strip, creating a triangle shape.

STEP 3
Using the first triangle as a guide, continue folding the strip back and forth in a triangular pattern, aligning the edges with each fold.

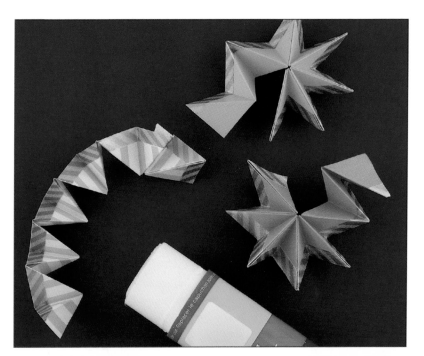

STEP 4

Once the entire strip is folded, it's time to assemble the star. To create the star shape, apply glue to alternating inside folds starting at one end of the strip, and press each together. Make sure that the side of the strip with the slim tape along the edge is positioned along the outside edge of the star. Each glued fold will become a point of the five-point star.

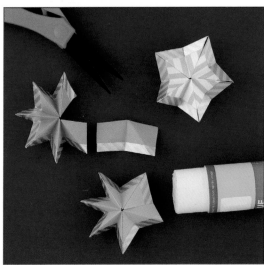

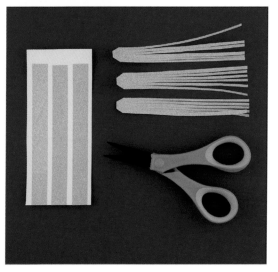

STEP 5

From the fifth point you glue, count two triangles (one square), and cut off the excess paper. Overlap the two ends to finish the star shape. Glue into place and allow to dry.

STEP 6

To transform the star into a shooting star, make a sparkly tail! Apply three 5"-long strips of glitter tape to paper. Cut out the tape strips, trimming the corners of the top edge at an angle. Then create a fringe by making long cuts from the bottom edge up to about ½" from the top edge.

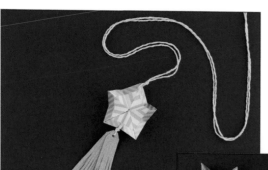

STEP 7

Punch a hole in the top of each glitter strip. String onto a piece of twine or ribbon; secure with a knot. Then punch a hole in the top and bottom of the star. String the star onto the twine above the glitter tape strips, and if desired, tie a second knot on top of the star.

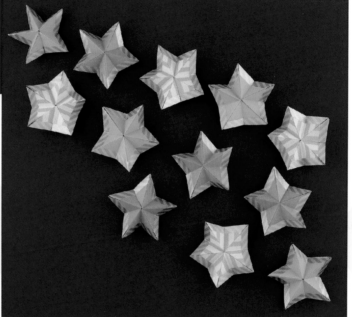

MAKE IT A GARLAND!

The only thing prettier than one shooting star is a whole string of them! Determine how long you'd like your garland to be. Cut a corresponding length of thin ribbon or pretty twine. Attach shooting stars at evenly spaced intervals, approximately 4 to 6 inches apart.

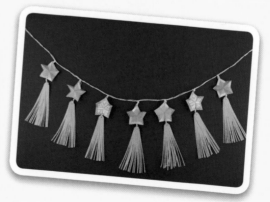

BEAUTIFUL BEADS

My favorite projects transform simple materials into objects that are both beautiful and useful. These beads are the perfect example! Plain printer paper, pretty tape, and a bit of time result in beads that you'll be proud to wear. Classic rolled paper beads get an upgrade with a little washi love! String beads into long necklaces, stacks of bracelets, or wear your favorites as dangly earrings.

TOOLS & MATERIALS

- 8¹/₂" x 11" Paper
- Washi tape
- Scissors
- Toothpicks
- Mod Podge® (glossy)
- Paintbrush

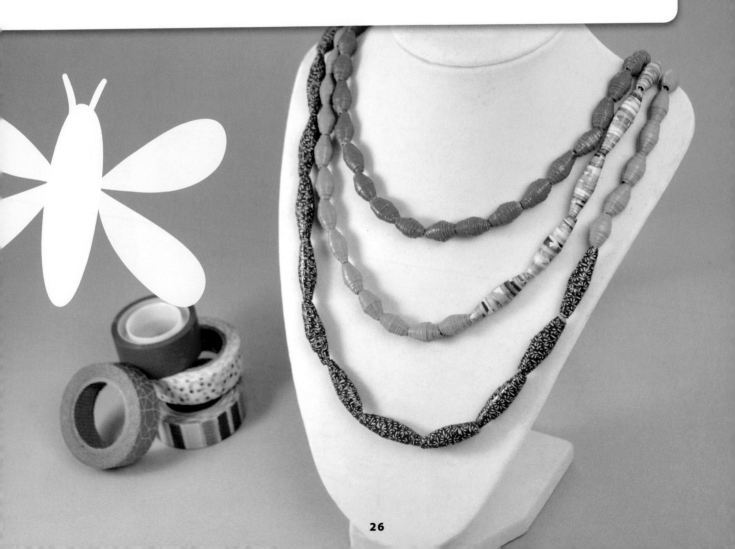

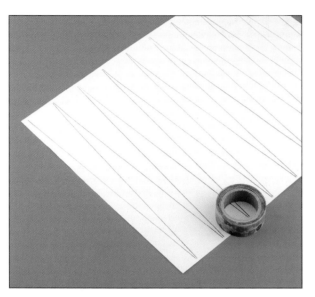

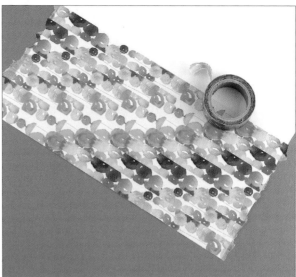

STEP 1

Use a ruler to draw a series of long triangles, as shown above, onto a piece of 8½" x 11" paper. For smaller beads, make narrower triangles.

STEP 2

Turn the paper over and cover the other side with strips of washi tape. Align the long edges of tape so that they don't overlap.

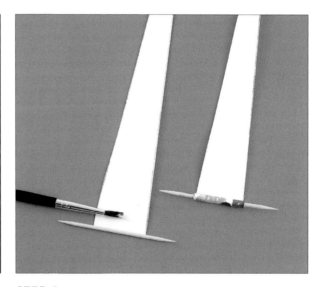

STEP 3

Flip the paper over again, and cut along the lines to make triangular strips. Slightly trim the sharp edges on the wide ends of the strips.

STEP 4

Align a toothpick with the wide end of the paper triangle. Apply a small amount of Mod Podge to the paper, approximately ¼" from the end. Roll the paper around the toothpick.

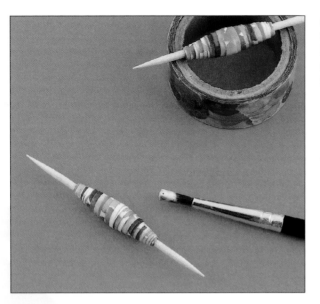

STEP 5

Continue rolling the paper around the toothpick, applying Mod Podge periodically, until it is all rolled up into a bead. Then apply a layer of Mod Podge over the entire surface, and allow to dry thoroughly.

STEP 6

Once dry, remove the toothpicks. You can string the beads onto a cord to make necklaces and bracelets, or use your favorites to make one-of-a-kind earrings!

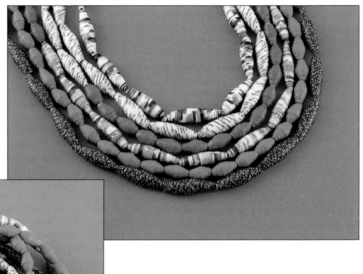

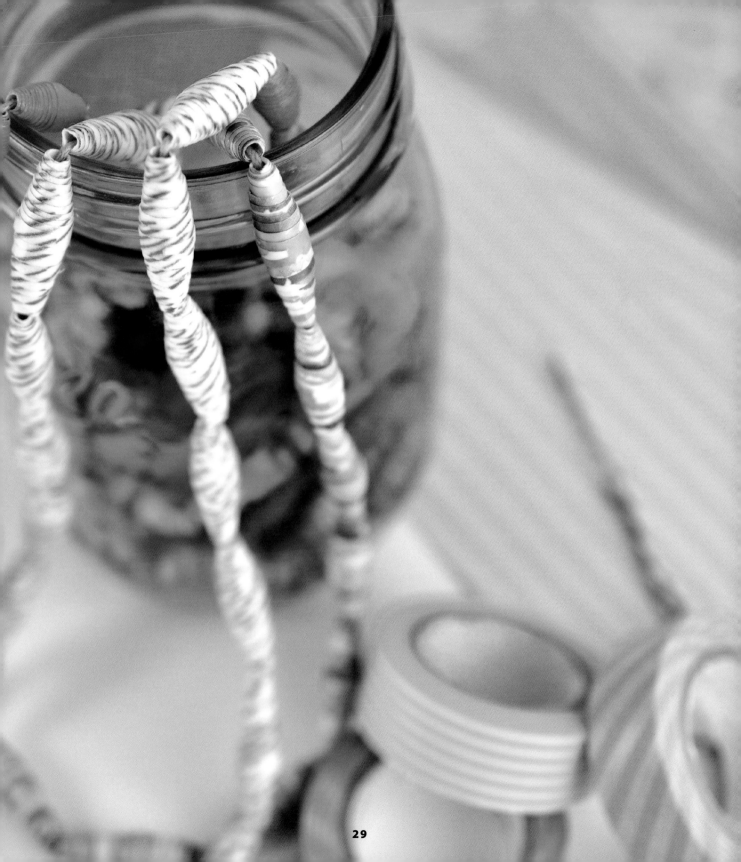

PARTY ANIMAL PAPER PUPPETS

* * * * * * * * * * * * * * * * * * * *

Who wouldn't be delighted to receive a handmade paper puppet on their birthday? These adorable animals are dressed up in their washi-tape finest and ready to celebrate. I've created two of my favorite animals—a panda and a cat—in puppet form, but the template provided is a basic shape, so you can transform it into whatever animal or person you please. Draw on floppy bunny ears, deer antlers, or even a ballerina bun. Then add your favorite details to bring these party animals to life.

TOOLS & MATERIALS

- Card stock
- Washi tape
- Scissors
- Markers
- Small hole punch
- Brads
- Small fasteners
- 12" dowel

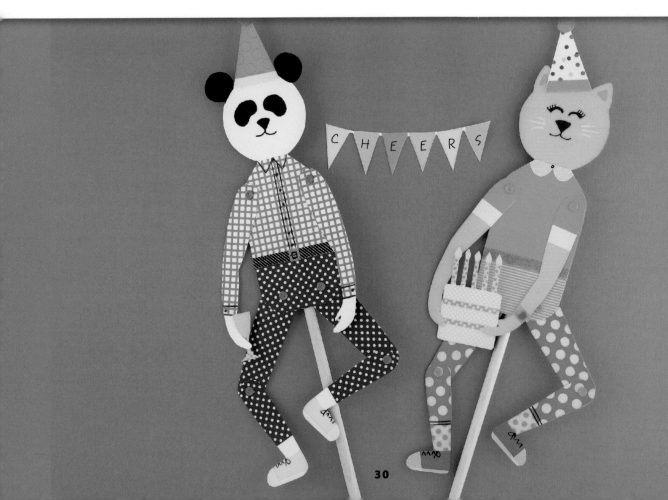

STEP 1

Outline a basic puppet shape onto a piece of light-colored card stock.

STEP 2

Dress the puppet's arms, legs, feet, and body in washi tape.

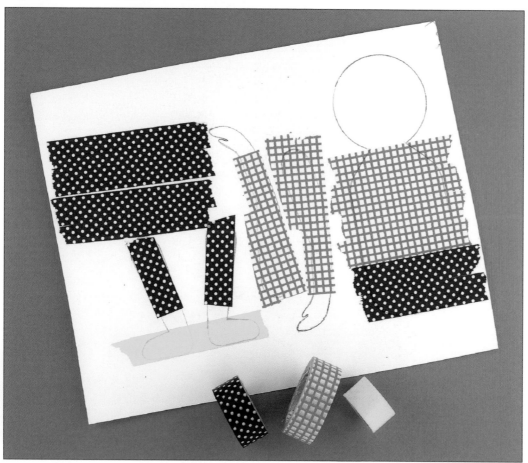

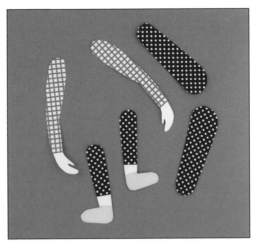

STEP 3

Cut out the legs and arms, cutting on the inside of any trace lines.

STEP 4

Draw special features, such as ears, and add a face.

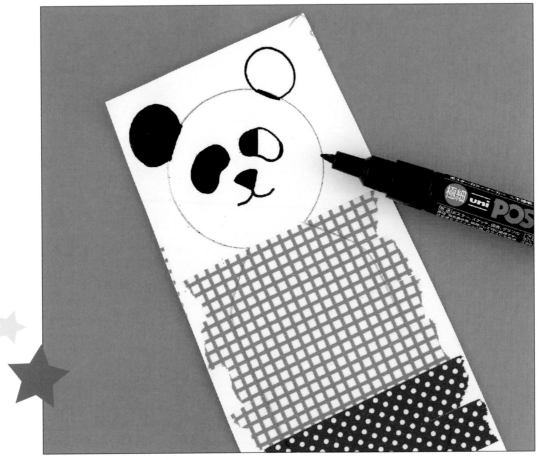

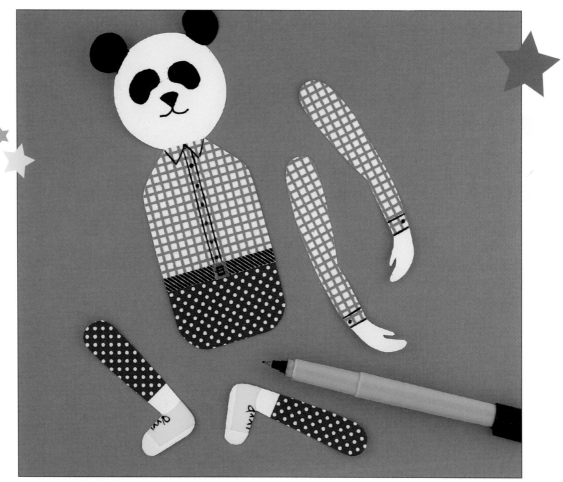

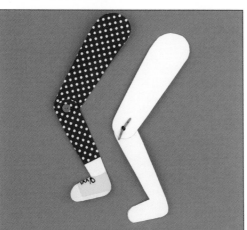

STEP 5

Cut out the head and body of the puppet. Then use small pieces of washi tape and a fine-tip marker to add details to the pieces.

STEP 6

Connect the lower and upper leg by placing the lower leg so that it overlaps the bottom of the upper leg to form the knee. Punch a hole in the knee, and place a brad through the hole, opening the tines to secure.

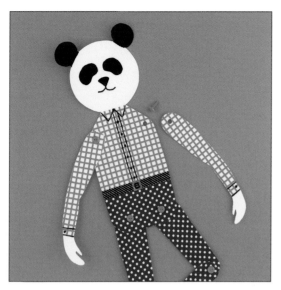

STEP 7
Repeat with the second leg, and connect the legs to the pelvis with brads. Then connect the arms with brads.

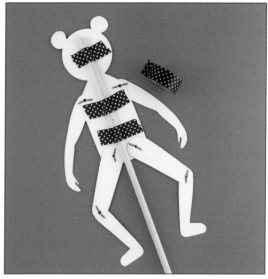

STEP 8
Flip the puppet over, and place the dowel down the center of the body. Secure it in three places with strips of tape. Make sure not to apply tape over any brads.

PARTY ANIMAL BIRTHDAY CARDS

For a simpler take on the party animals, turn them into birthday cards! Draw animal faces on card stock. Then then cut the faces out and glue onto brightly colored blank cards. Finish with patterned party hats cut from washi tape-covered card stock. Pretty cute, right? Even better, these cards are as fun to make as they are to receive!

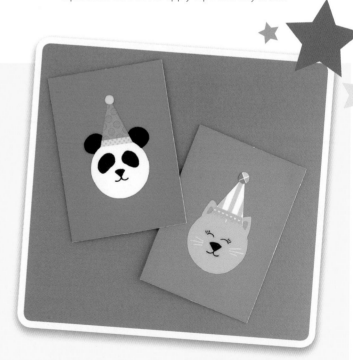

STEP 9
If desired, create party accessories by cutting shapes from washi tape-covered card stock. These removable accessories can be taped to the puppets.

CHEERS

TIMELESS TEACUP CARDS

✳ ✳ ✳ ✳ ✳ ✳ ✳ ✳ ✳ ✳ ✳ ✳ ✳ ✳ ✳ ✳ ✳

I have long been enamored with blue-and-white dishes. They just never go out of style! Since my cupboards can't hold every piece of blue-and-white china I fall in love with, I couldn't resist putting tape to paper to create my own collection. These clever cup-shaped cards are a wonderful way to send someone a hello by snail mail, and they are perfect for a tea party invitation. No matter how you use them, the recipients are sure to be amazed that you made them out of tape!

TOOLS & MATERIALS

- Card stock
- Pencil
- Bone folder
- Ruler or other straight edge
- Washi tape
- Craft knife
- Scissors
- Parchment or wax paper

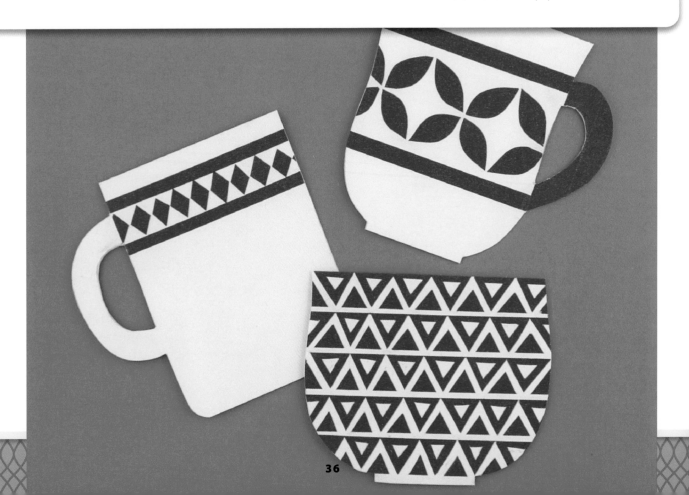

Getting Started

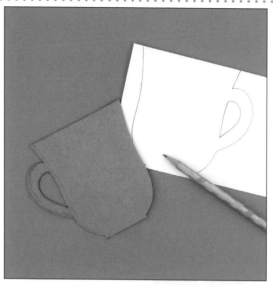

Start with a piece of blank card stock. Use a bone folder and ruler to score the card stock lengthwise, and then fold it in half.

Trace your desired cup shape onto the card stock. Align the cup shape so that the top of the cup is at the fold of the card stock.

TIP

To cut small tape strips or shapes, apply the tape on parchment or waxed paper. When you're ready to use the tape shapes, simply peel off the paper backing.

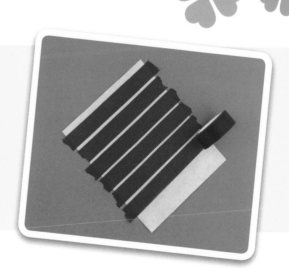

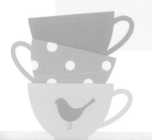

Vintage Flower Design

Recreate midcentury modern-inspired flowers with angled petals in an X formation, or create your own floral pattern. It's easy!

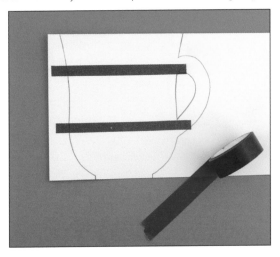

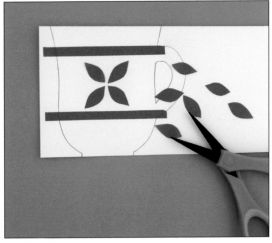

STEP 1

Apply two thin strips of tape across the width of the cup, leaving approximately 1¾" between the strips. You can use slim washi tape or cut standard-width tape in half.

STEP 2

Apply washi tape to parchment or wax paper, and cut out petal shapes from the covered paper. You will need approximately 10 petals. Arrange the petals on the cup. When you are happy with the arrangement, peel off the paper backings, and stick the petals in position.

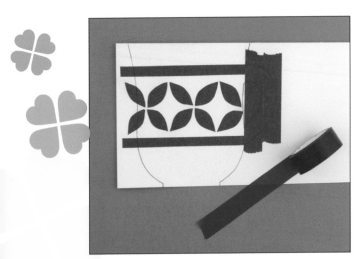

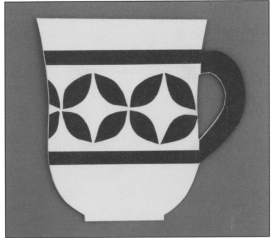

STEP 3

Cover the handle of the teacup in strips of washi tape, aligning the tape strips so that there are no gaps or overlapping edges.

STEP 4

Cut out the cup shape. Use the craft knife to cut out the enclosed section of the handle.

Retro Diamond Design

This simple but striking design is inspired by classic diner mugs.

STEP 1
Cut a piece of standard-width (⅝") washi tape lengthwise into three thin strips. Apply two of the thin strips of washi tape to the top of the mug, leaving approximately ½" to ⅝" between the strips.

STEP 2
Make diamond shapes for the pattern. To make mini diamonds, first cut the end of your washi tape on a diagonal. Make a second cut about ¾" from the first to form a diamond. Cut that diamond in half and then in half again to make four mini diamonds.

STEP 3
Arrange the diamonds between the two stripes on the mug.

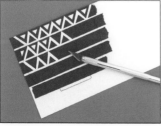
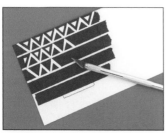

Modern Geometric

The tape version of a hand-painted piece of pottery, the geometric pattern in this design is a free-form creation. If you prefer your patterns a bit more on the perfect side, grab a ruler!

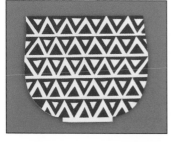

STEP 1
Apply five strips of washi tape across the width of the cup, leaving a small space between each strip.

STEP 2
Now use a craft knife to create a design in the strips. Refer to my example, or create your own pattern! Use a light touch. You want to just barely cut through the tape, without cutting the card. Carefully peel and discard pieces of tape to reveal your pattern.

STEP 3
Work carefully to complete the design across the cup.

5 WAYS TO PLAY: SIMPLE ERASER STAMPS

✳ ✳ ✳ ✳ ✳ ✳ ✳ ✳ ✳ ✳ ✳ ✳ ✳ ✳ ✳

The office supply store is a great place to source unlikely craft supplies. Basic erasers make a wonderful addition to your craft kit. Whether you carve patterns into them, cut them into geometric shapes, or simply use them as is, erasers are bursting with crafty potential. Pair with a vibrant ink pad for extra fun! Here are five fun ways to play with pattern using eraser stamps.

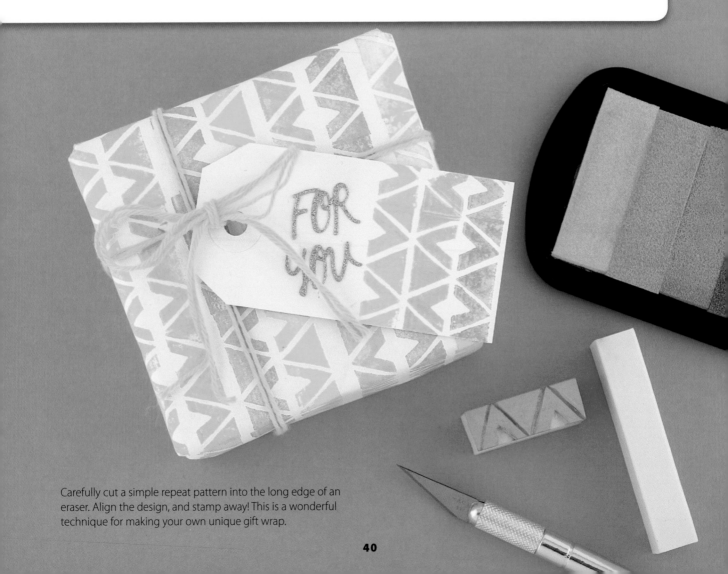

Carefully cut a simple repeat pattern into the long edge of an eraser. Align the design, and stamp away! This is a wonderful technique for making your own unique gift wrap.

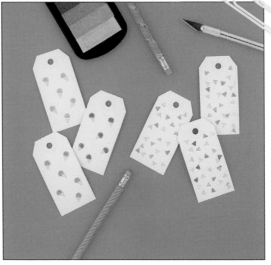

The eraser end of a regular pencil makes perfect polka dots. Create a colorful confetti pattern on envelopes and send a party in the mail!

Use a craft knife to carefully carve pencil erasers into mini stamps. Keep it simple with shapes like triangles, raindrops, and semicircles. These minis are a fun way to build a playful pattern on gift tags.

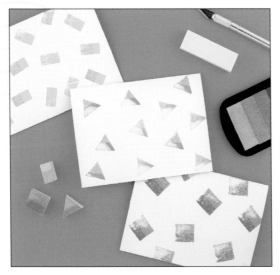

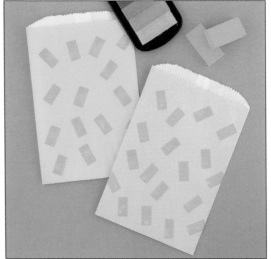

Cut a standard eraser into simple geometric shapes, such as triangles and squares. Add some interest to everyday cards by stamping shapes in two colors at once.

The unused end of a standard eraser is perfect for creating patterns and designs. Transform basic paper bags into something more festive with a multicolor confetti print.

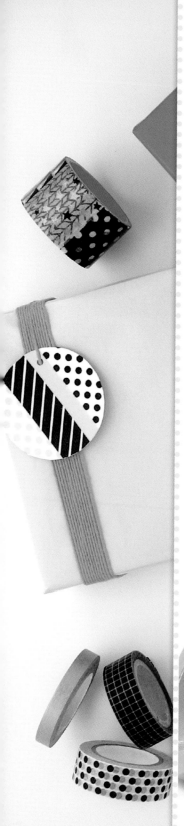

WRAP

* * * * *

Wrapping a gift should be just as fun as picking it out. Make your gifts the best dressed at the party by creating unique gift toppers, color-dipped gift tags, pretty paper bags, and clever pouches.

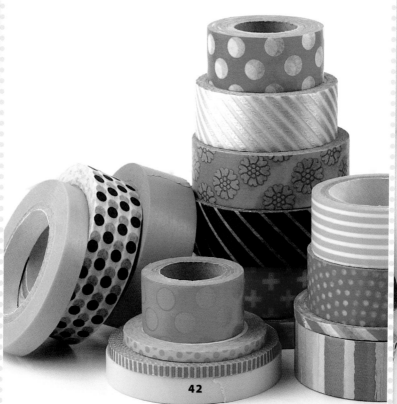

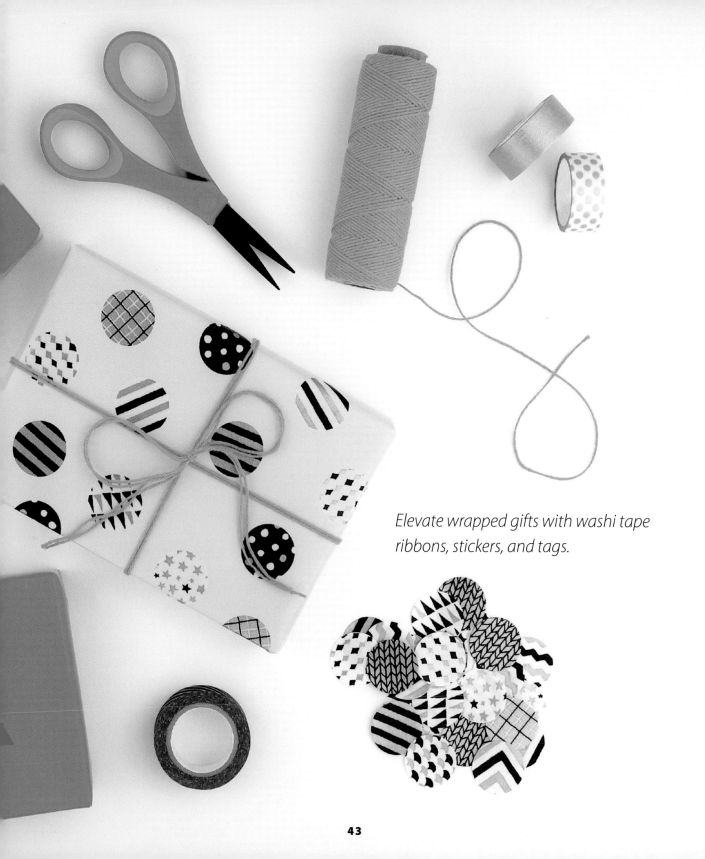

Elevate wrapped gifts with washi tape ribbons, stickers, and tags.

COLOR-DIPPED PAPER TAGS

These simple yet pretty tags look dipped in color, but without any of the fuss (or mess) of dip dyeing. Use two tapes in the same color family for a modern look or go bold with contrasting colors. Once you start making your own gift tags, you'll never want to buy them again! Create different looks by applying more or less washi tape, decorating with stamps or stickers, or cutting the tags out of pretty, patterned paper.

TOOLS & MATERIALS

- Card stock
- Washi tape
- Pencil or marker (optional)
- Scissors
- Hole punch

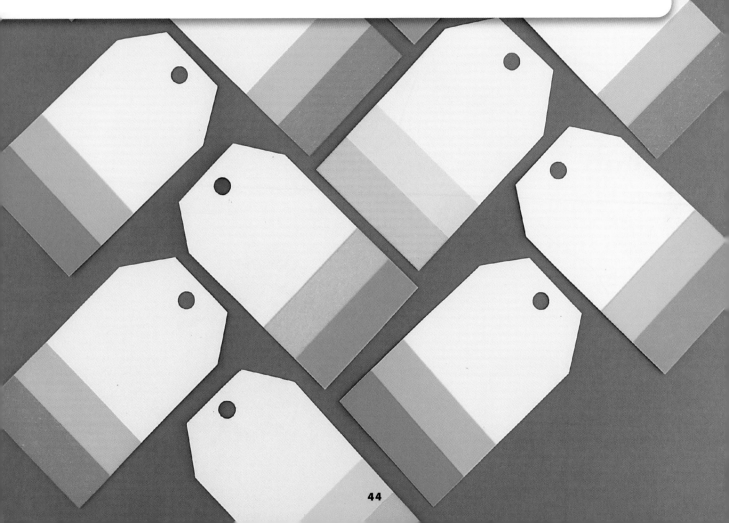

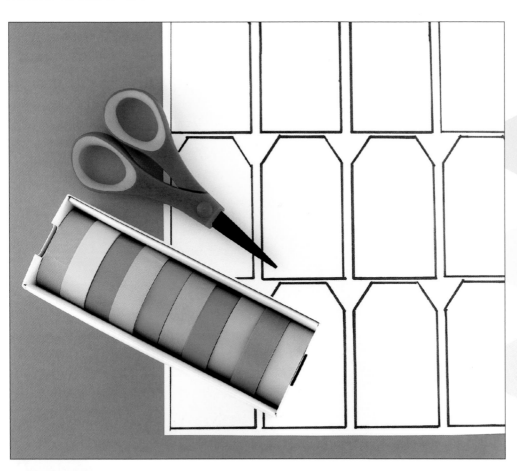

STEP 1

Trace tag shapes onto a piece of card stock.

STEP 2

Apply a strip of washi tape along the bottom edge of the tag shapes. Apply a second strip of a complementary tape just above the first, being careful to align the edges without overlapping.

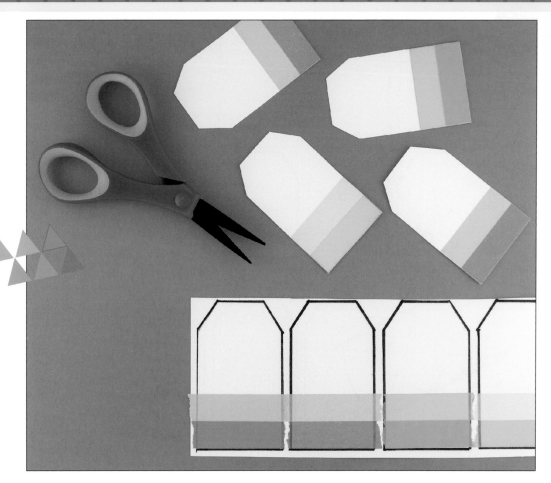

STEP 3

Cut out the tags, making sure to cut slightly just inside the lines.

STEP 4

Punch a hole in the top of each tag. They are ready to attach to gifts with twine or ribbon!

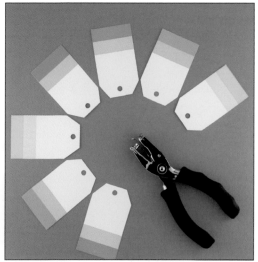

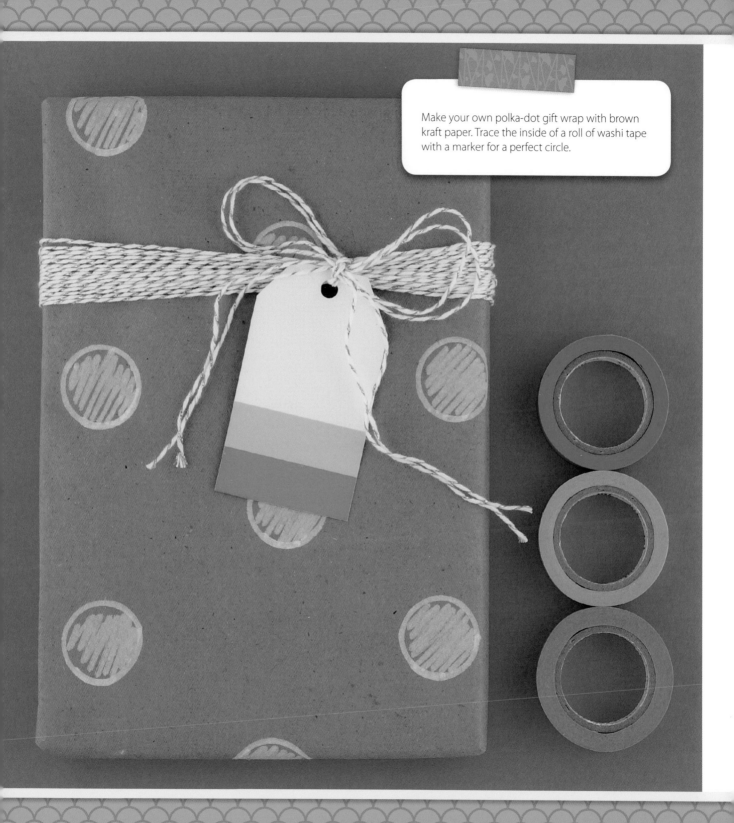

Make your own polka-dot gift wrap with brown kraft paper. Trace the inside of a roll of washi tape with a marker for a perfect circle.

PATTERNED PAPER BAGS

* * * * * * * * * * * * * *

Handmade paper bags are a wonderful way to wrap smaller items without sacrificing style. Make one to match a special gift, or spend an afternoon crafting a whole stack so you'll always have pretty wrapping on hand! If you collect patterned or scrapbook paper, you'll love this useful project—plus these clever bags can also be used as envelopes!

TOOLS & MATERIALS

- Pencil
- Patterned paper
- Scissors
- Bone folder (optional)
- Ruler (optional)
- Glue
- Washi tape

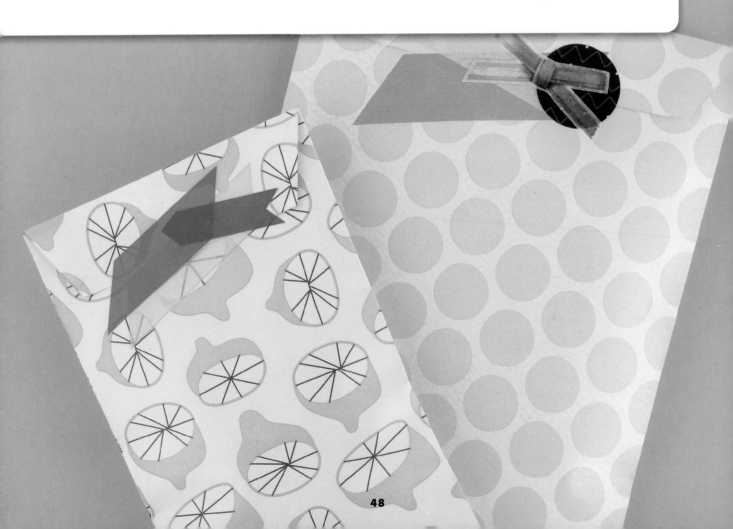

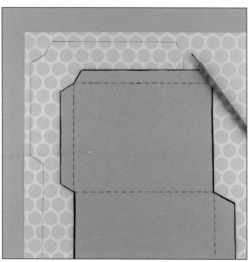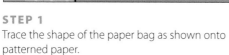

STEP 1
Trace the shape of the paper bag as shown onto patterned paper.

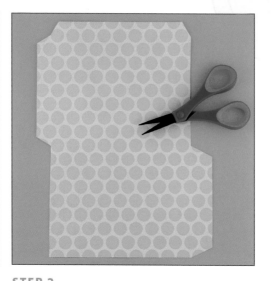

STEP 2
Cut out the paper bag shape. Try to cut slightly on the inside of your traced lines so that you don't need to erase pencil marks.

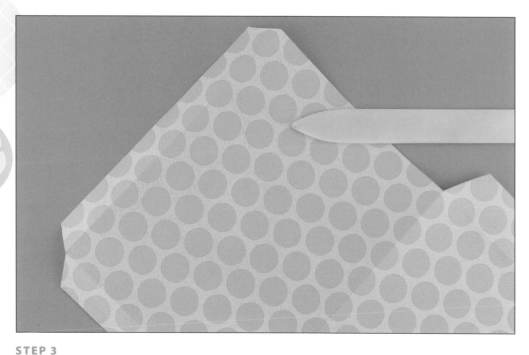

STEP 3
Fold the paper bag along the dotted lines indicated above. Then unfold. For precise folds, use a bone folder and ruler to score and fold.

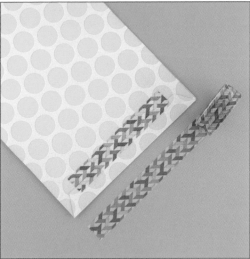

STEP 4

To form the body of the bag, apply glue to the patterned face of the side flap. Fold the right half of the bag over the left, sandwiching the glued flap in between.

STEP 5

Flip bag over. Fold up the back flap and secure with glue or washi tape. Allow the glue to dry thoroughly before filling the bag.

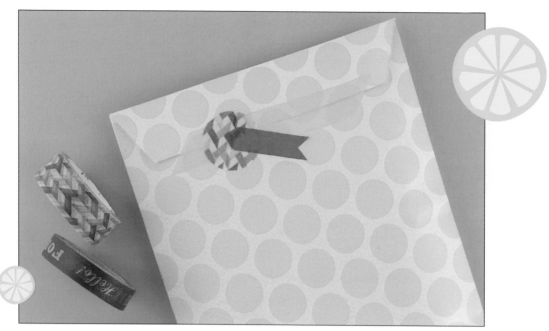

STEP 6
Fill the bag with the contents of your choice. Then secure the top flap with washi tape. Try layering a few different strips and shapes for a more decorative look.

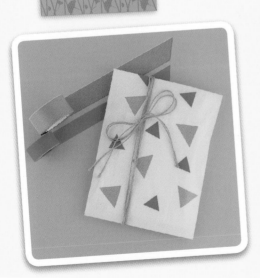

DECORATE A BASIC BAG
No time to make your own paper bags? Washi tape to the rescue! Use washi tape strips and shapes to add personality to plain paper bags.

TRIPLE-TIER LACE BOWS

The wedding cake of paper bows, these lovely, lacy gift toppers
are filled with frills and delicate details. A few folds and a strip
of pretty tape are all you need to transform dollar-store doilies
into the prettiest bows in town. Go bold with colored doilies to
dress up birthday gifts with frilly toppers.

TOOLS & MATERIALS

• 3 paper doilies in various sizes
• Scissors
• Washi tape

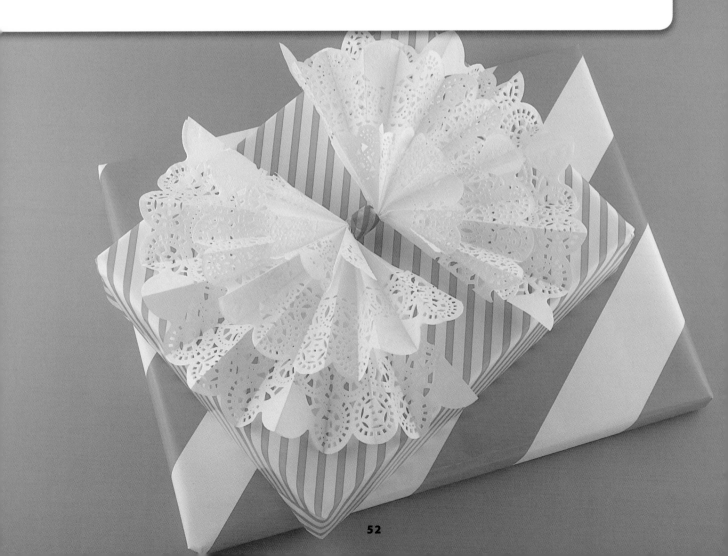

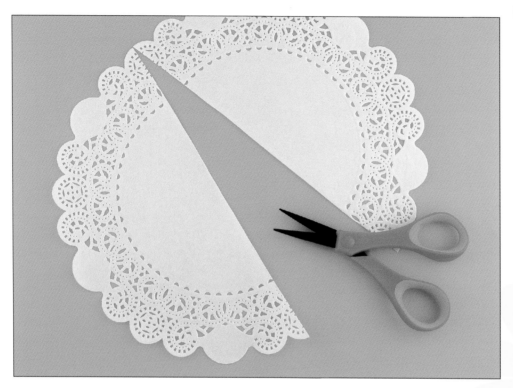

STEP 1

Fold the largest doily in half. Then unfold, and cut it in half along the fold.

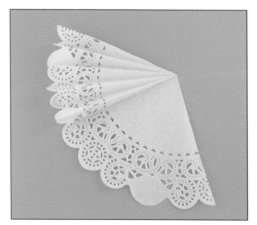

STEP 2

Fold one of the doily halves in half. Working from the center point of the flat side, fold the doily back and forth to create a fan shape. Each folded segment should have a triangular shape.

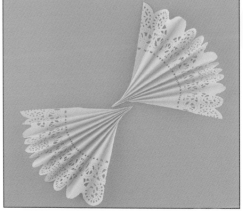

STEP 3

Repeat with the other doily half. Try to match the number of folds on each side.

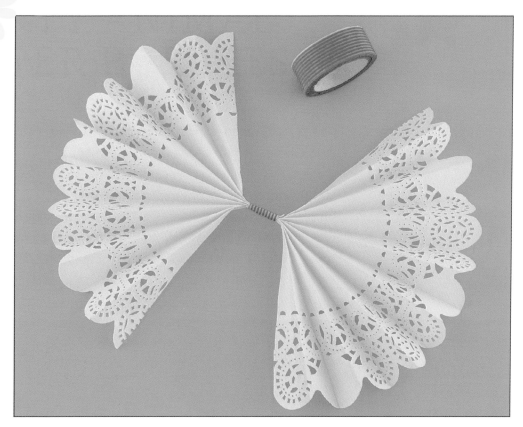

STEP 4

Use a small strip of washi tape to join the two halves of the bow at the center. For a more secure bow, overlap the two doily points before taping.

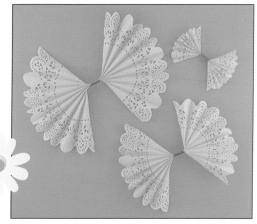

STEP 5

Repeat steps 1 through 4 with the other two doilies.

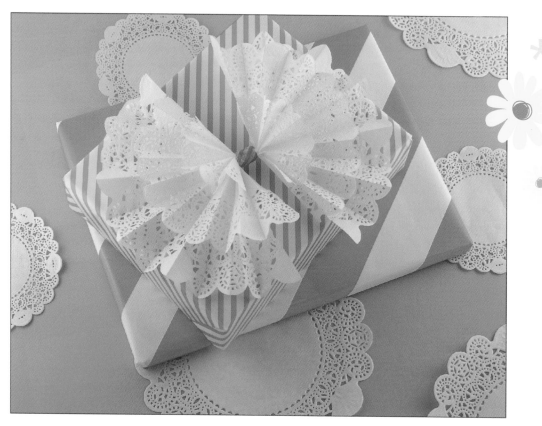

Layer the bows on top of each other. Press the center slightly between your fingers to flatten. Wrap a strip of washi tape around the centers of the three bows to form one single bow. Now it's ready to top any gift!

MAKE IT SIMPLE!
Love the look of the lace paper bow but think all that triple-tiered goodness is overwhelming your gift? Make it simpler by making it smaller. Simply craft one bow out of a single doily, rather than three.

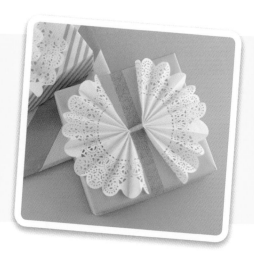

PAPER LANTERN GIFT TOPPER

Gift bags are an easy wrapping solution, but they can be a bit boring. Why not tie on a magical paper lantern instead of a tag? Grab a handful of your favorite washi tapes, and put them to work making unique gift toppers inspired by paper lanterns. These seasonless stunners are perfect for any occasion and can easily be reused as ornaments.

TOOLS & MATERIALS

- Washi tape
- Paper (8$\frac{1}{2}$" x 11")
- Scissors
- Small hole punch
- Twine, string, or thin ribbon
- Beads

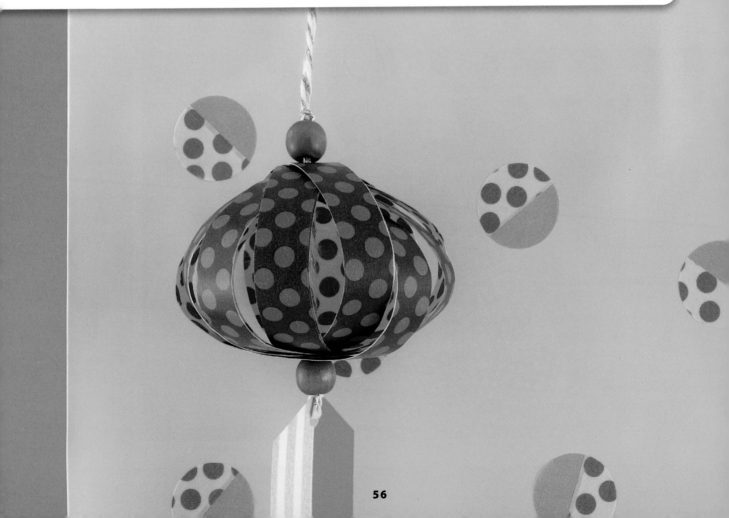

STEP 1

Apply six strips of washi tape to one side of a piece of paper. Flip the paper over, and apply six strips of another tape to the other side of the paper.

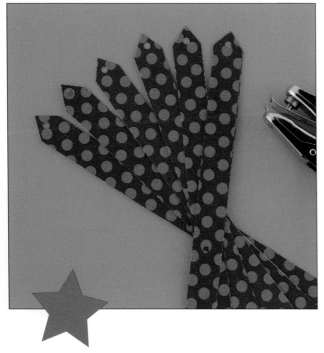

STEP 2

Cut out tape-covered strips, and trim both ends into a point. Then punch a hole in both ends of each strip and a third hole in the center.

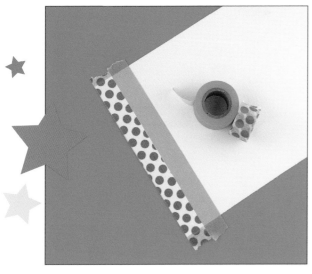

STEP 3
Next apply two 5" strips of washi tape on a new piece of paper, aligning the edges.

STEP 4
Flip the paper over, and apply two strips of tape to the other side. Then cut out a tag shape, with a pointed top and a notched bottom. Punch a hole in the center of the pointed top.

STEP 5
Cut a piece of twine approximately 24" long. Fold it in half and use a piece of washi tape to join the two ends. This will make it easier to thread the twine.

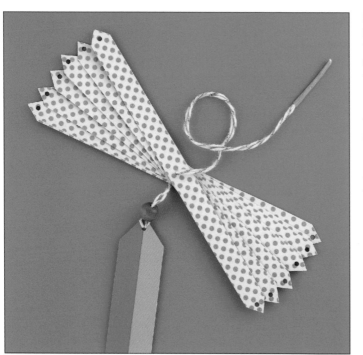

STEP 6

Loop the twine through the hole in the tag, and secure it by passing the taped end through the looped twine. String a bead onto the twine above the tag. Then string the six strips onto the twine so that the outside tape pattern is facing down and the inside tape pattern is facing up.

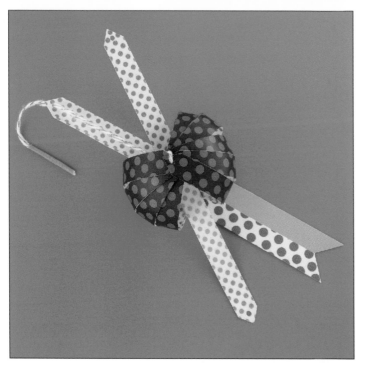

STEP 7

Fan out the lantern strips. Working with one strip at a time, thread the twine through the holes in the ends of the strips, forming the round lantern shape. Start with the bottommost strip, and feed the twine through the hole at one end of the strip, followed by the hole on the other end. Work from the bottom up.

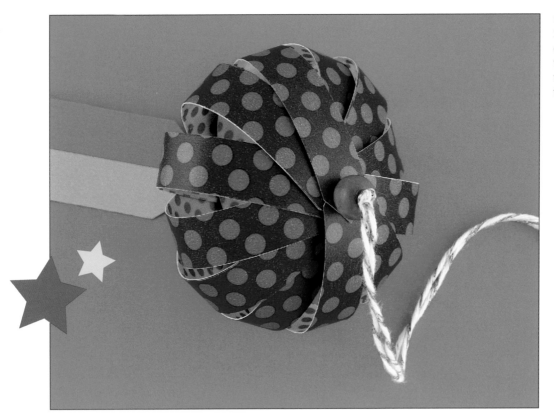

STEP 8
String another bead onto the twine at the top of the lantern, and tie a knot in the twine to secure.

PURELY ORNAMENTAL

These clever paper lanterns can also double as party decorations for your next celebration or as ornaments for your holiday tree. You can even use them as pulls on your favorite table lamps. If you're crafting a whole party's worth, try using pretty paper rather than washi tape. Simply skip the tape step and cut the paper into 5/8"-wide strips.

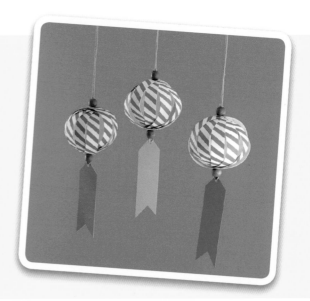

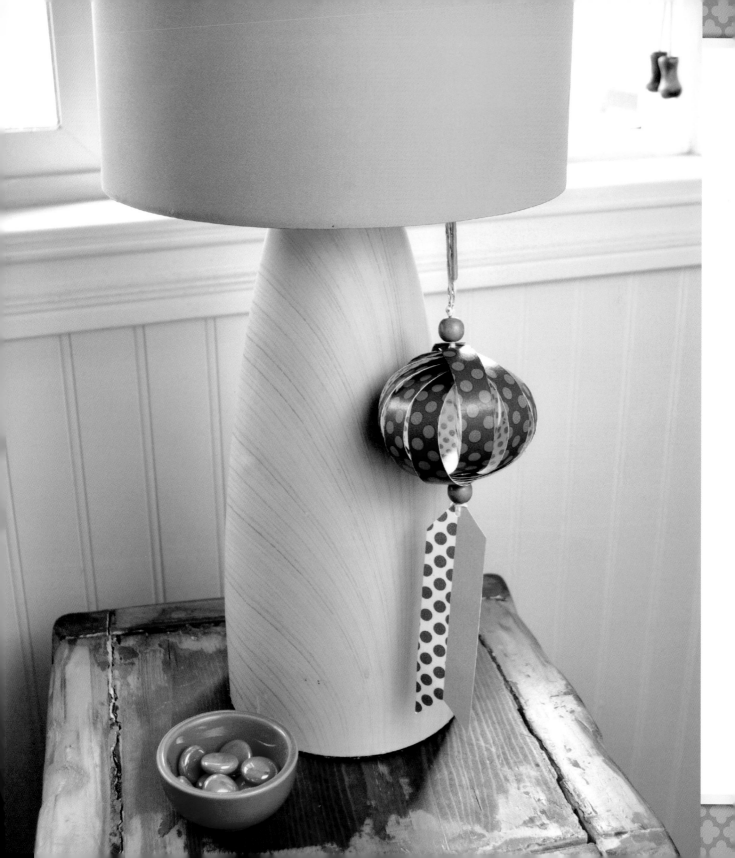

PAPER PYRAMID POUCHES

* * * * * * * * * * * * * * * * * * *

Cute triangular paper pouches are an easy but impressive way to wrap up small treats. Candy, confetti, tiny toys, and sweet notes will be well received when packaged in a pretty pyramid. Washi tape plays well with all kinds of paper, but I'm especially smitten with how it combines with origami paper. So many pretty patterns to choose from...so many fantastic combinations to try!

TOOLS & MATERIALS

- Origami paper (6")
- Scissors
- Washi tape

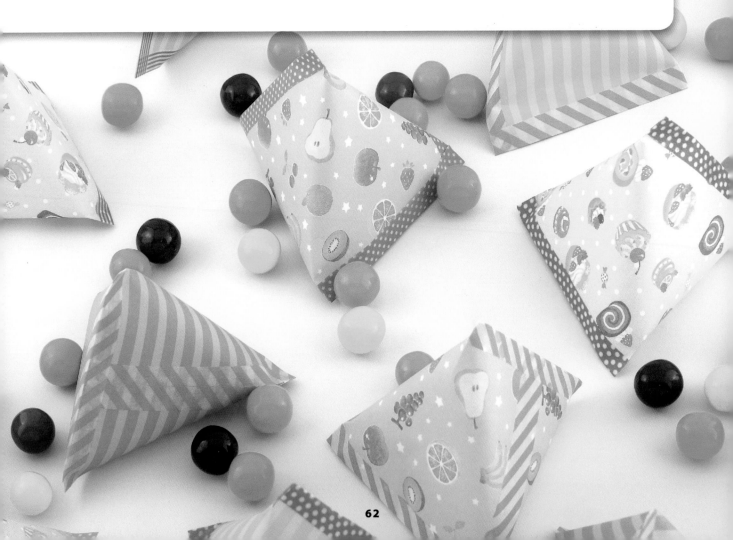

STEP 1

Fold a piece of origami paper in half. Then unfold, and cut along the fold line.

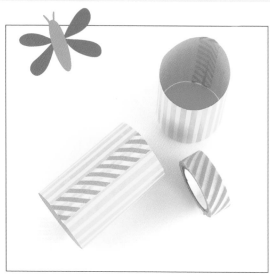

STEP 2

Join the two short edges of the rectangle together to form a tube. Secure with a piece of washi tape, and trim the tape ends.

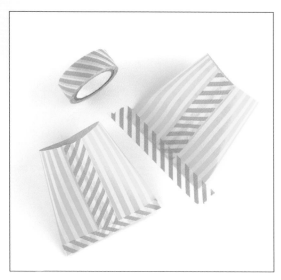

STEP 3

Position the tube so that the taped seam is in the center. Flatten one end, and fold a piece of washi tape over it. Trim the tape ends.

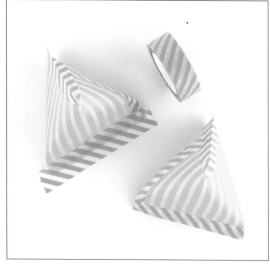

STEP 4

Fill the pouch with the desired items. Then rotate the pouch so that the taped seam is facing the side. Flatten the open end of the pouch, creating the pyramid shape. Seal with a piece of washi tape, and trim the tape ends.

MAKE IT BIGGER!

No origami paper on hand? Need a bigger pouch? No problem! You can use any paper you please. Simply start with a piece of paper that is twice as long as it is wide. This piece of standard 12" scrapbook paper made a 6" pouch.

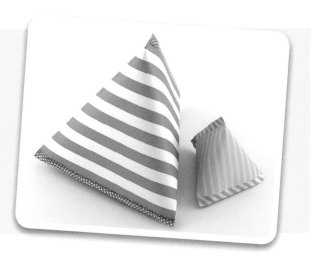

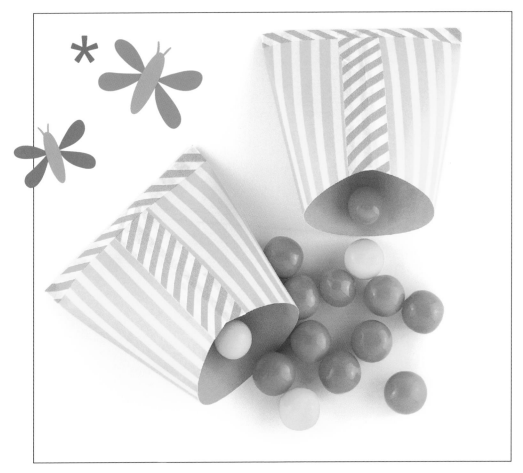

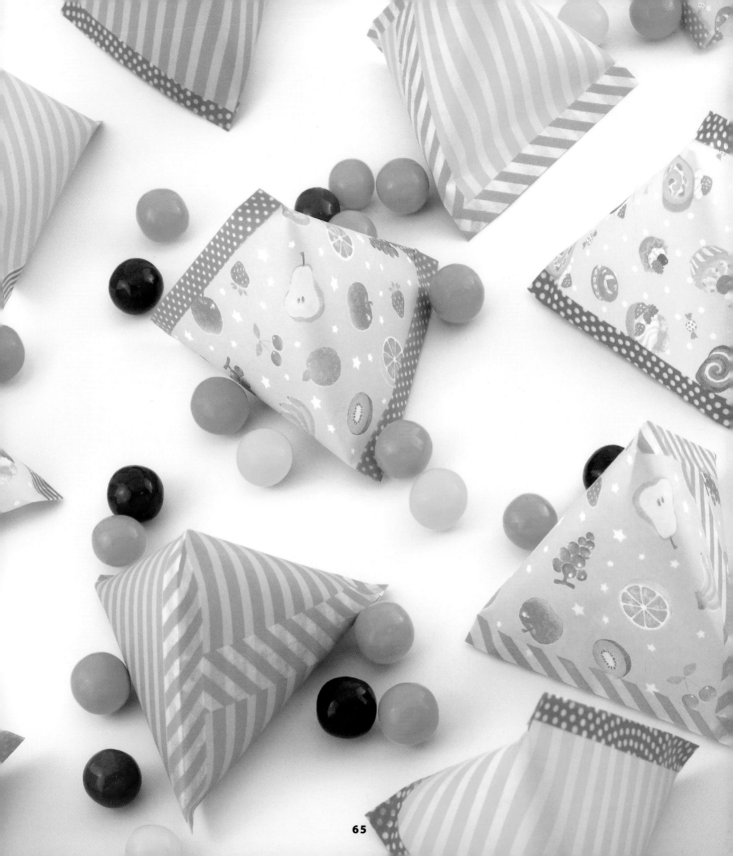

5 WAYS TO WRAP: WASHI TAPE & KRAFT PAPER

* *

Washi tape and basic brown kraft paper make fantastic friends. With a roll of kraft paper and a handful of washi tape in your craft cupboard, custom gift wrap is always just a few minutes away. There are infinite ways to wrap with washi tape and kraft paper. Here are five ideas to get you started.

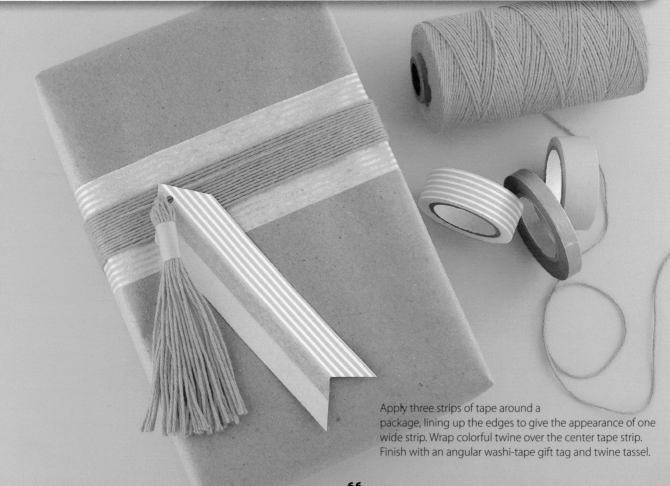

Apply three strips of tape around a package, lining up the edges to give the appearance of one wide strip. Wrap colorful twine over the center tape strip. Finish with an angular washi-tape gift tag and twine tassel.

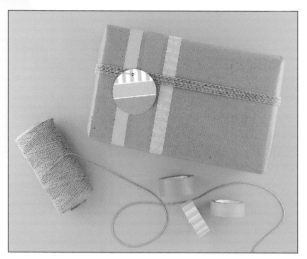

Wrap three evenly spaced strips of washi tape in complementary designs around your package. Next wrap colorful twine around the gift in the opposite direction. For the finishing touch, punch or cut out a matching gift tag from washi tape-covered card stock.

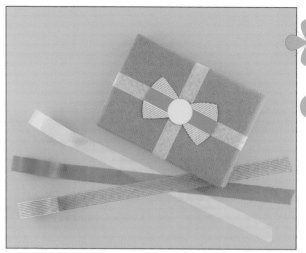

Two intersecting strips of washi tape take the place of ribbon in this classic gift look. Top with a bow cut from washi tape-covered card stock.

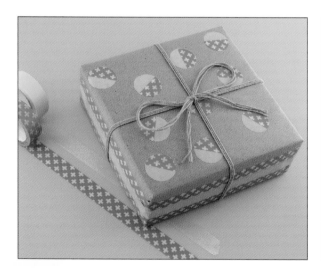

Wrap long strips of washi tape around the sides of the box. Then decorate the top with matching washi tape dots. Tie colorful twine or ribbon around the package. See page 7 and page 88 for tricks to punching shapes out of washi tape.

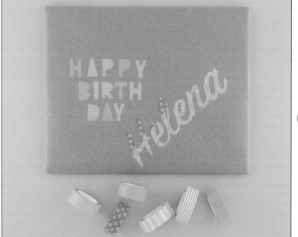

Write your message directly on the gift. Mix different lettering styles and tape designs for a modern look. Learn how to create your own washi-tape text in the "Write" section beginning on page 114.

DRAW

* * * * *

Thinking of washi tape as an art material, rather than simply tape, opens up a whole world of creative possibilities. In this section, we'll use washi tape to color in cute paper dolls, make sweet fruit stickers, create a variety of patterns, learn essential techniques for drawing with tape, and even use tape as the canvas.

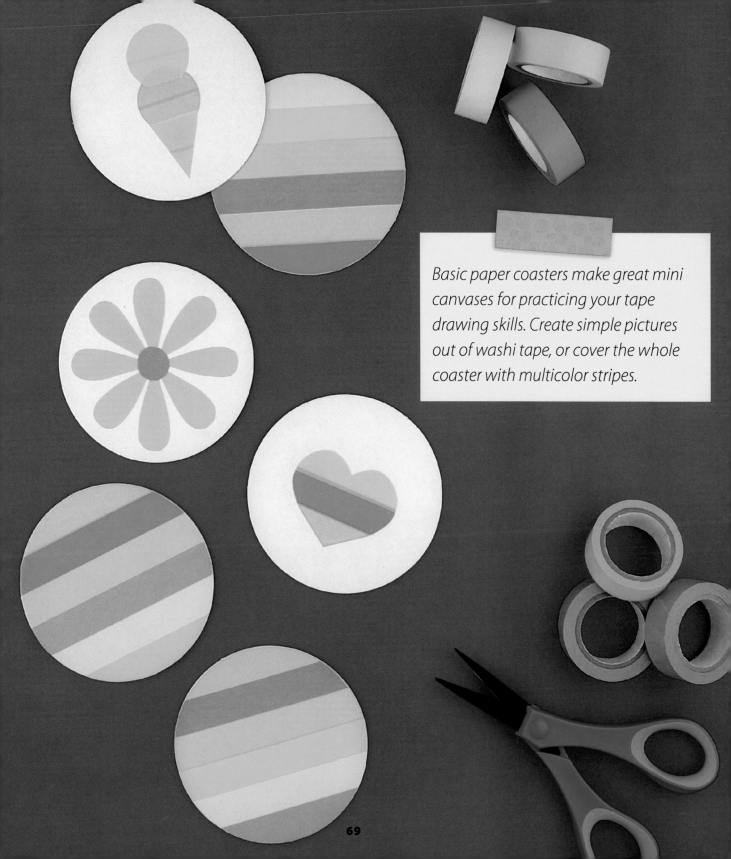

Basic paper coasters make great mini canvases for practicing your tape drawing skills. Create simple pictures out of washi tape, or cover the whole coaster with multicolor stripes.

PRETTY PAPER DOLLS

✳ ✳ ✳ ✳ ✳ ✳ ✳ ✳ ✳ ✳ ✳ ✳ ✳ ✳ ✳ ✳

Cute paper dolls dressed in washi tape designs are a delight to make. Inspired by classic wooden dolls like *kokeshi* and *matryoshka*, you can mix and match different colors and patterns to make your own unique version! Display a set of dolls, or use these cuties as gift tags or greeting cards. Using washi tape to color in pictures is a great technique to master. Once you're comfortable, you can use this technique to add your favorite washi designs to almost any picture.

TOOLS & MATERIALS

- Card stock
- Washi tape
- Craft knife
- Markers
- Scissors

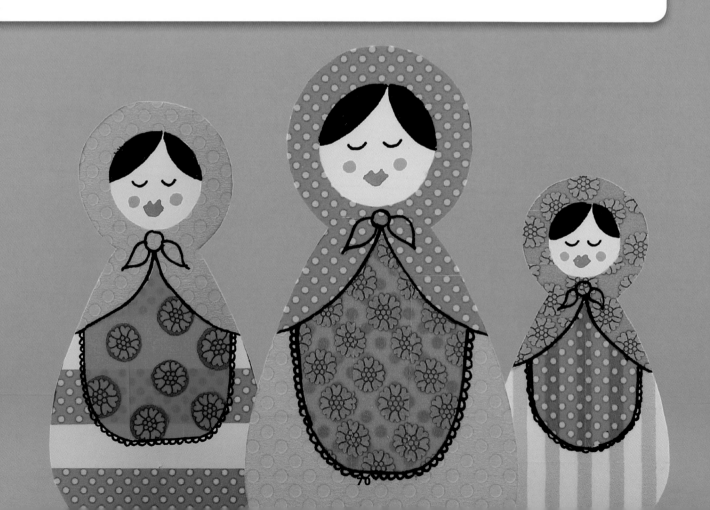

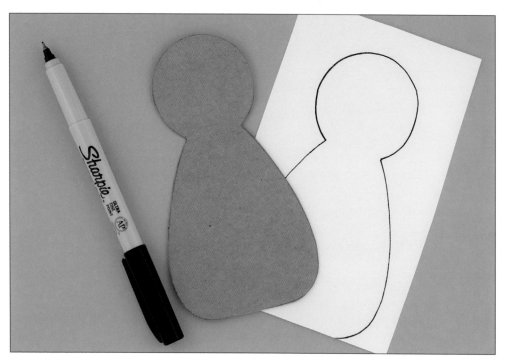

STEP 1

Outline a basic doll shape onto card stock. Use a dark marker or pen so you can see the outline through the washi tape.

TIP

When drawing on washi tape, use permanent or paint markers to avoid smearing.

STEP 2

Choose a washi tape design for the head scarf. Cover the top half of the doll with strips of tape. Align the tape so that edges meet without overlapping. Try to match the pattern where possible.

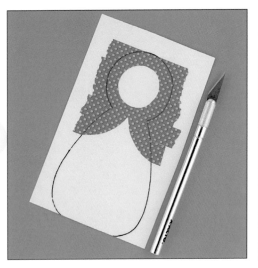

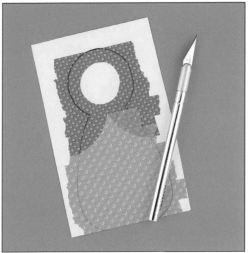

STEP 3

Use a craft knife to lightly cut through the tape to shape the bottom of the scarf. Peel off the excess tape. Then cut out a circle for the face. Use a light enough touch to cut only the tape and not the paper underneath.

STEP 4

Choose a washi tape design for the doll's dress, and cover the rest of the doll from the neck down with tape, aligning the edges without overlapping. Then use a craft knife to cut along the edge of the scarf. Carefully remove any extra tape.

TIP

When working on a project where you need to remove tape from paper, test to ensure that your tape and paper are a good match first. Although washi tape can be easily removed from most papers, it occasionally rips the paper surface.

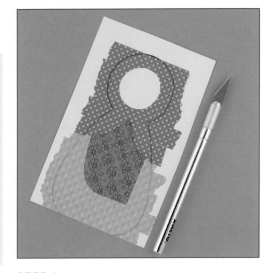

STEP 5

To make the apron, apply three strips of tape lengthwise from the neck to approximately 1" above the bottom edge. Use a craft knife to trim the apron shape and clean up the edges around the scarf. Carefully peel away extra tape.

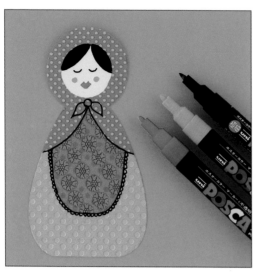

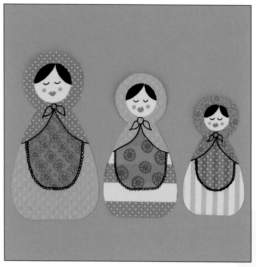

STEP 6

Use scissors to cut out the doll, cutting slightly inside the line. Use markers to draw the face and add apron details. Allow the ink to dry between colors.

STEP 7

If desired, repeat with the smaller dolls to make a set.

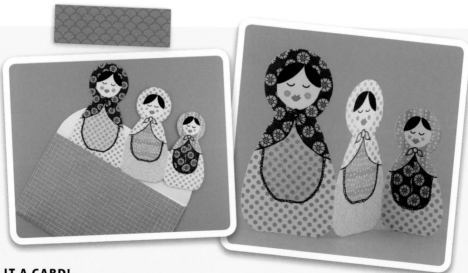

MAKE IT A CARD!

Create a clever folding card using the same coloring techniques. Outline three dolls that are touching onto card stock, and use washi tape and markers to color in the dolls. Cut out and fold back and forth along the joins. Write your message on the blank backs, and then fold and mail. The final card stands easily and is a gem to display!

MODERN
GEOMETRIC MOSAICS

* * * * * * * * * * * * * * * * * *

Need a little more art in your home? Make mosaics! In these simple designs, basic washi tape shapes combine to create striking graphic arrangements that can be hung with pride. Choose two contrasting colors for greater impact. Pick your favorite design, or make all three! These mosaic patterns can also be applied to blank cards, notebooks, and gift wrap.

TOOLS & MATERIALS

- Washi tape
- Scissors
- Paper
- Card stock

Diamond Weave

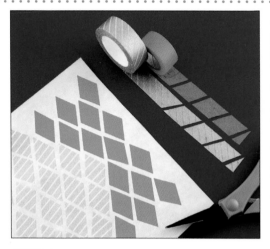

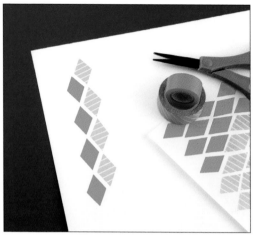

STEP 1

Working with tape on the roll, cut the tape end on an angle. Make a second parallel cut to create the diamond shape. You can pre-cut the shapes and store on a piece of backing paper (as shown) or cut and stick as you build your mosaic.

STEP 2

Apply four diamonds down the left side of the paper. Using a different color, position a second row of four diamonds in the spaces created by the first row. Leave white space between each diamond and a border at the side and top.

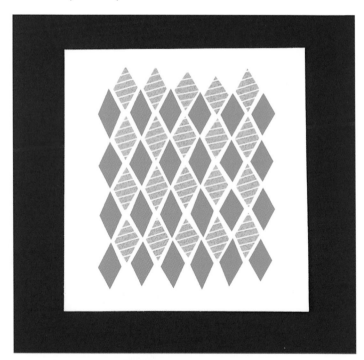

STEP 3

Continue adding rows of diamonds in alternating colors until you have a square arrangement. Trim the paper to the final size and shape you desire.

Cube Squared

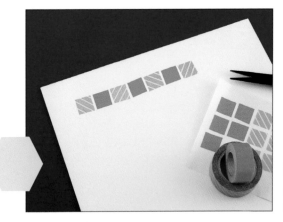

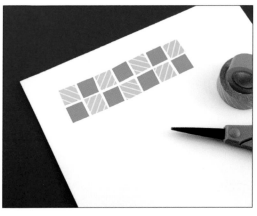

STEP 1

Cut simple squares out of the washi tape. Try to keep the length of the squares equal to the tape's width for symmetry. Apply the first line of squares across the top of the paper in alternating colors. Keep squares evenly spaced and aligned.

STEP 2

Apply a second row of squares below the first, alternating colors again.

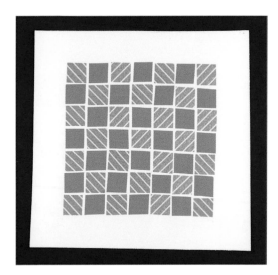

STEP 3

Continue applying squares in alternating colors until you have an equal number of rows and columns. Cut the paper to the final desired size.

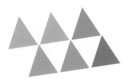

TIP

I prefer to use card stock or another heavier paper with a smooth surface for this type of project. Choose paper that allows you to remove and reposition pieces of tape easily and without damage.

Color-blocked Gem

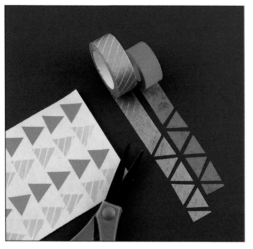

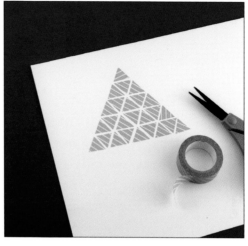

STEP 1

Start by cutting evenly sized triangles out of washi tape. Store your pre-cut shapes on a piece of backing paper, or cut and stick as you build your mosaic.

STEP 2

Center a triangle at the top of your paper, leaving space above it for a border. Build a second row below it out of three triangles, with every other triangle pointing down. Add three more rows of triangles, increasing each row by two.

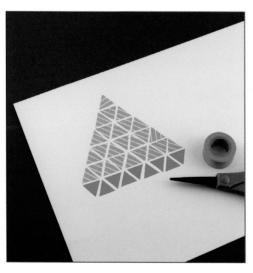

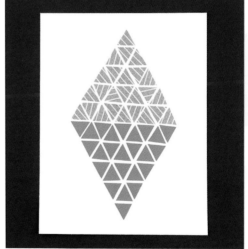

STEP 3

Below the fifth row of triangles, start building the bottom half of the diamond with a contrasting color of tape. This time, each subsequent row will decrease by two triangles.

STEP 4

Once the final triangle is placed on the bottom point, cut the paper to the desired size and shape.

CLOUDS PATTERN PLAY

Love patterns? Create your very own playful cloud pattern with washi tape, a bit of paper, and some clever cutting. This colorful project is the perfect opportunity to display your favorite washi tape designs in an unconventional way. Try mixing bright neon colors with soft metallic and bold black and white for a modern palette, or dream up your own theme.

TOOLS & MATERIALS

- Parchment or wax paper
- Pen or marker
- Washi tape
- Scissors
- Card stock

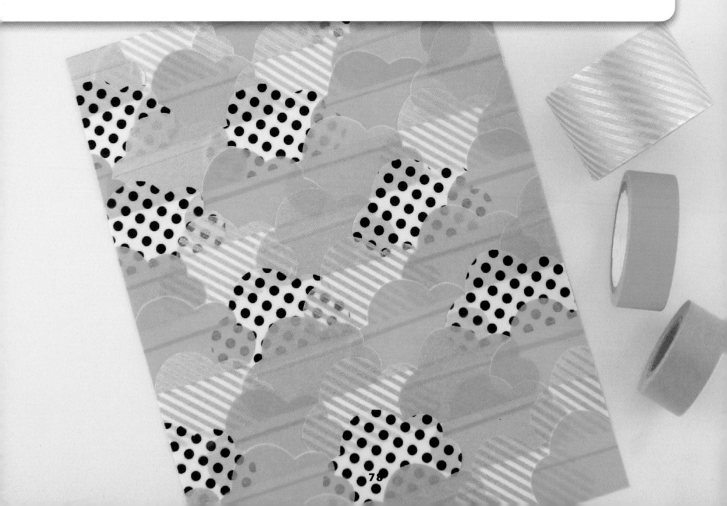

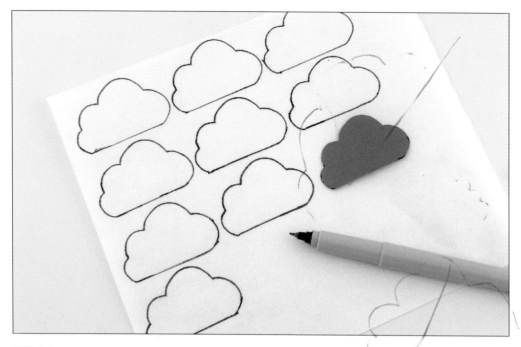

STEP 1
Trace cloud shapes onto wax or parchment paper. Use a dark pen or marker that is visible on the opposite side of the paper.

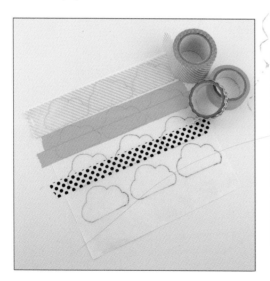

TIP
For this project, I recommend card stock over regular paper because it is easier to reposition washi tape stickers on a heavier paper without wrinkling or tearing the surface.

STEP 2
Flip the paper over, and cover the clouds with washi tape.

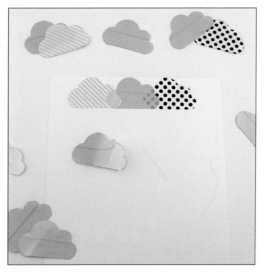

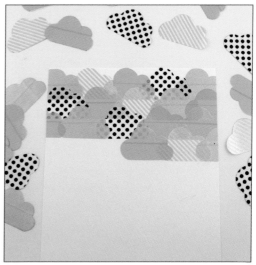

STEP 3

Cut out the cloud stickers. Then prep a piece of card stock that is slightly larger than the final desired size. For 5" x 7" artwork, for example, trim card stock to 6" x 8".

STEP 4

Carefully peel the tape clouds off the paper backings, and stick them to the card stock. Work from the top down, completing one row at a time and alternating among colors and patterns.

MAKE IT A NOTEBOOK!

The best thing about washi tape shapes is that they are full of potential. Why not apply a grouping of clouds to the front of a plain notebook? For extra fun, use an eraser stamp to add raindrops. Learn how to make your own on page 38. The finished notebook is perfect for jotting down dreams and rainy-day plans.

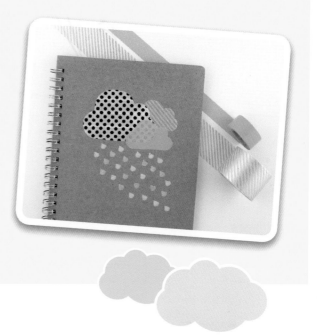

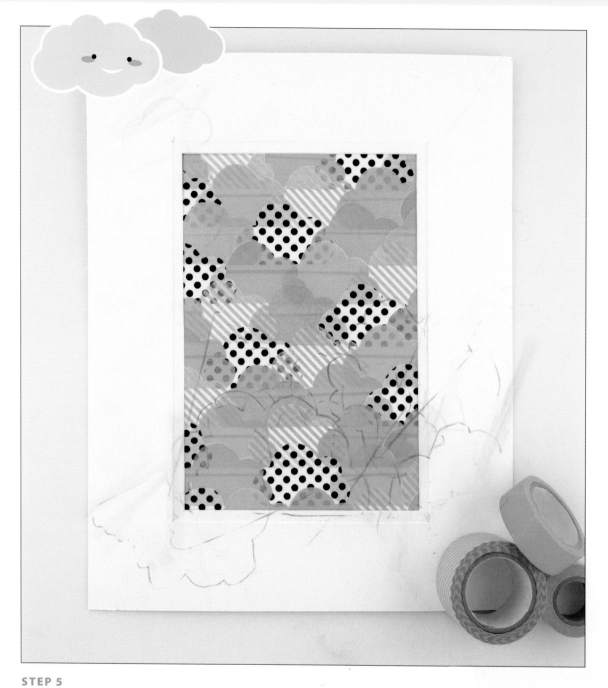

STEP 5

Fill the entire surface of the paper to complete your pattern, and trim the paper to the final size you would like. For a finished look, display your pattern in a matted frame.

FRUIT SALAD STICKERS

Drawing is always more fun when you draw with tape! Bold colors, easily recognizable shapes, and simple details combine in this adorable—and sticky—project. Fruit stickers make sweet accents for decorating snail mail, handmade cards, gift wrap, stationery, and even around the house. Wouldn't that jar of strawberry jam in your fridge be extra delicious dressed up in strawberry stickers?

TOOLS & MATERIALS

- Washi tape
- Parchment or wax paper
- Scissors
- Fine-tip permanent marker

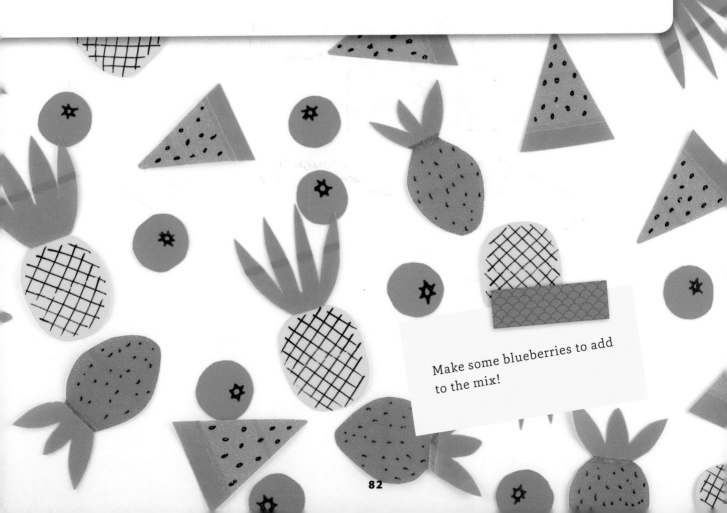

Make some blueberries to add to the mix!

Watermelon Stickers

 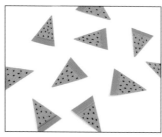

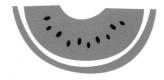

STEP 2

Draw on watermelon seeds. If desired, gently round the top point with scissors.

STEP 1

Apply a strip of green washi tape to your preferred backing paper. Then apply two pink strips, slightly overlapping the edges. Cut the green strip in half lengthwise. Then cut the tape into triangle shapes with green bottoms and pink points.

Strawberry Stickers

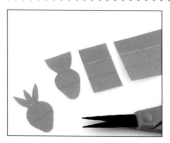 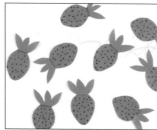

STEP 2

Use a fine-tip marker to draw seeds on the strawberries.

STEP 1

Apply two strips of red washi tape to backing paper, slightly overlapping the edges. Apply a strip of green washi tape, slightly overlapping the edge of the red strip. Cut tape into pieces about 1½" wide. Trim out the strawberry shapes with rounded berries and a few green leaves.

Pineapple Stickers

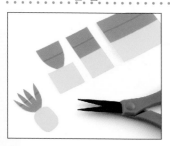 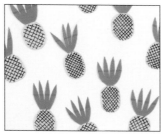

STEP 2

Use a fine-tip marker to draw intersecting lines on the pineapples.

STEP 1

Apply two strips of yellow washi tape to backing paper, slightly overlapping the edges. Apply two strips of green tape, overlapping the edges. Cut pineapple shapes out of tape using the same method as for the strawberries.

RAINBOW
SKETCHES

✳ ✳ ✳ ✳ ✳ ✳ ✳ ✳ ✳ ✳ ✳ ✳ ✳ ✳ ✳

I love drawing to increase creativity and decrease stress, but plain white sketchbook pages can get a little dull. Colorful washi tape to the rescue! Fill your page with color before drawing by applying tape to the full page. Choose all the colors of the rainbow, or create your own color scheme. Love this idea? You can always lift it out of the sketchbook and apply to canvas or useful objects instead.

TOOLS & MATERIALS

- Paper or sketchbook
- Washi tape
- Black and white markers

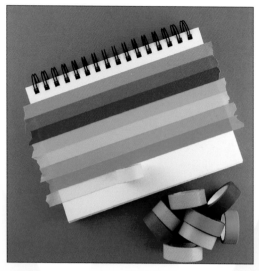

STEP 1

Cover a sketchbook page in strips of washi tape. Adhere strips so that edges align without any gaps or overlaps.

STEP 2

Wrap tape edges around to the back of the page.

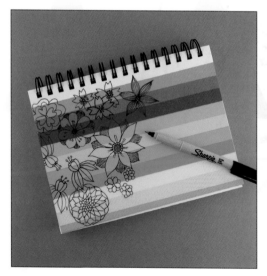

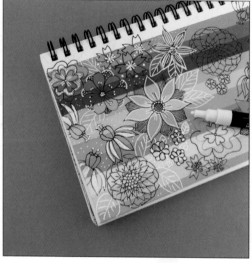

STEP 3

Draw on top of the tape with a black marker. Be careful when going over tape edges as they may snag on the marker tip.

STEP 4

Draw in details with a white marker. This helps your illustration "pop off" the page, especially when drawing over dark tape colors.

DRAW ANYTHING WITH WASHI TAPE

Creating pictures out of washi tape is a great way to challenge yourself while also using and displaying your favorite tapes. I like to think that you can draw pretty much anything with tape once you have a few techniques down. Here are three ideas to try that allow you to practice three different drawing methods. Once you're comfortable with these techniques, "draw" your own ideas, and use them to make handmade cards, cute wall art, and personalized objects.

TOOLS & MATERIALS

- Washi tape
- Paper
- Craft knife
- Ruler or straight edge
- Parchment or wax paper
- Scissors

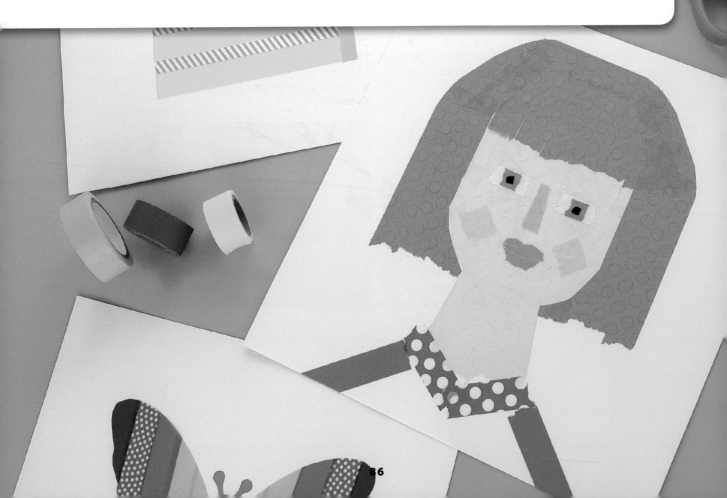

Torn-Tape Portraits

Make quirky, casual portraits using little more than torn pieces of washi tape.

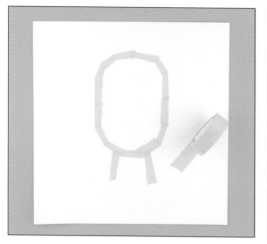

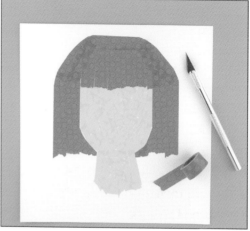

STEP 1

Create the outline of the face and neck using short strips of torn tape. If you're using a standard-width tape, tear each strip in half vertically and use the straight side for the outer edge of the face.

STEP 2

Tear small pieces of tape and fill the entire face and neck. Try not to leave any white space. Then draw hair, using long strips of tape, angling shorter strips over the curve of the head. You can use a craft knife to carefully shape the top into a more realistic shape if you wish.

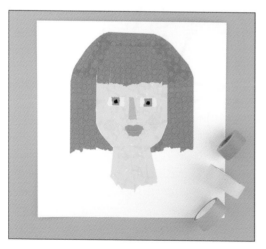

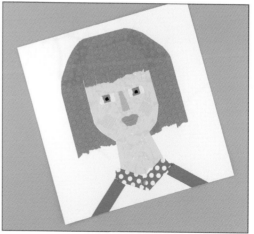

STEP 3

Fill in the facial features with torn shapes and squares. Layer different colors and sizes to make the eyes, and carefully tear tape into lip and nose shapes.

STEP 4

Finish the portrait by adding details, such as clothes and accessories.

Cut & Peel Layer Cake

Washi tape cakes make adorable birthday cards and are a fantastic way to practice shaping tape into pictures using the cut-and-peel technique.

STEP 1

Start by building the body of your cake. Apply alternating strips of standard-width and slim-width tape to represent the cake layers and filling, aligning the edges. Then use a craft knife to trim the two sides into straight lines.

STEP 2

Next add frosting. Apply a strip of tape along the right side of the cake. Trim the top and bottom edges to match the height of the cake layers. Next apply three strips to the top of the cake.

STEP 3

Carefully cut the frosting on the top of the cake into a wedge shape with a rounded, wide end. Use a ruler to keep the cut straight. Trim the tape on the right side to approximately half its original width. Peel and discard the extra tape pieces.

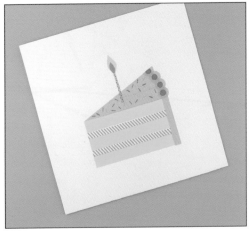

STEP 4

Decorate the slice of cake with frosting flourishes, sprinkles, and a pretty candle. Remember that it is easier to cut small shapes out of tape when you apply them to backing paper first.

Layered-Strip Butterflies

Colorful butterflies are simple to construct when you use the layered-strip technique.

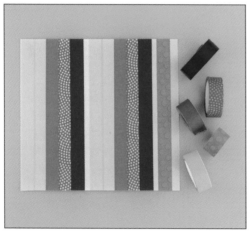

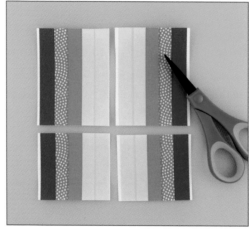

STEP 1

First prepare the tape to be cut into shapes, applying strips to a piece of backing paper in the desired color order. Each strip should slightly overlap the one before it. Repeat the tape pattern for the second set of wings. Apply a single strip of tape in the desired body color. I chose

STEP 2

Trim the paper with the tape for the body and set aside. Then cut the backing paper in half, and rotate one piece so that they are mirror images of each other. Cut each half into two pieces for the wings. The upper wing segments should be larger than the lower wing segments.

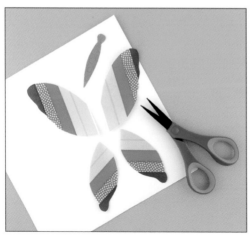

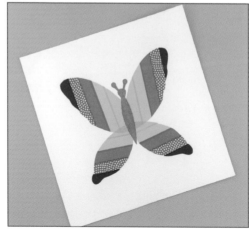

STEP 3

Cut the pieces into two upper wings, two lower wings, and a body. Make sure the wings are mirror images of each other. If you like, you can draw the wing shapes on the back of the backing paper before cutting.

STEP 4

Starting with the lower wings, peel the shapes off of the backing paper, and stick to your surface. Make sure you peel from the bottommost strip of tape first to keep the wing sticker in one piece. Finish by placing the body shape and antennae.

5 WAYS TO PUNCH

✳ ✳ ✳ ✳ ✳ ✳ ✳ ✳ ✳ ✳ ✳ ✳ ✳ ✳ ✳ ✳ ✳

Circle punches and hole punches are some of my favorite crafting tools. While elaborate punches are pretty, I find they can be a bit limiting. Circles, on the other hand, are full of crafty potential. Here are five creative ways to put your circle punches to use.

Make confetti! Punch confetti from colorful paper, and slip a handful inside outgoing mail or gift boxes. This festive addition is a great way to use paper scraps.

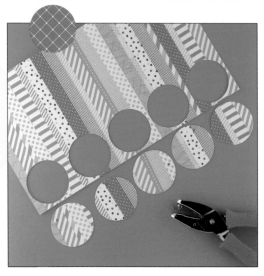

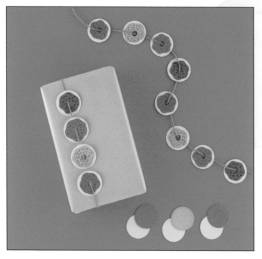

Cover card stock in strips of your favorite washi tape designs. Then punch 2" circles to make one-of-a-kind gift tags. Finish by punching a small hole to thread twine or ribbon through.

Adorable paper donuts make sweet garlands and gift toppers. Make a baker's dozen using a 1" circle punch, a standard hole punch, and a little glue.

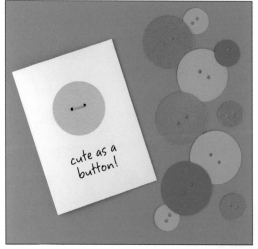

Washi tape dot stickers come in handy for all sorts of projects. Apply overlapping strips of tape onto backing paper. Place a piece of card stock behind the backing paper, and then punch.

Colorful card-stock buttons make sweet embellishments. Punch 1" or 2" circles out of card stock, and then punch two holes in the center of each with a small hole punch. Paper buttons look extra cute tied onto handmade cards!

MIX

✳ ✳ ✳ ✳ ✳

Tape and paper might be a fantastic combo, but that's no reason not to explore other possibilities. Try combining washi tape with unusual materials and traditional techniques. Create a colorful papercut bouquet, assemble modern collages, decoupage a set of magnets, or even make a pair of dynamic statement earrings.

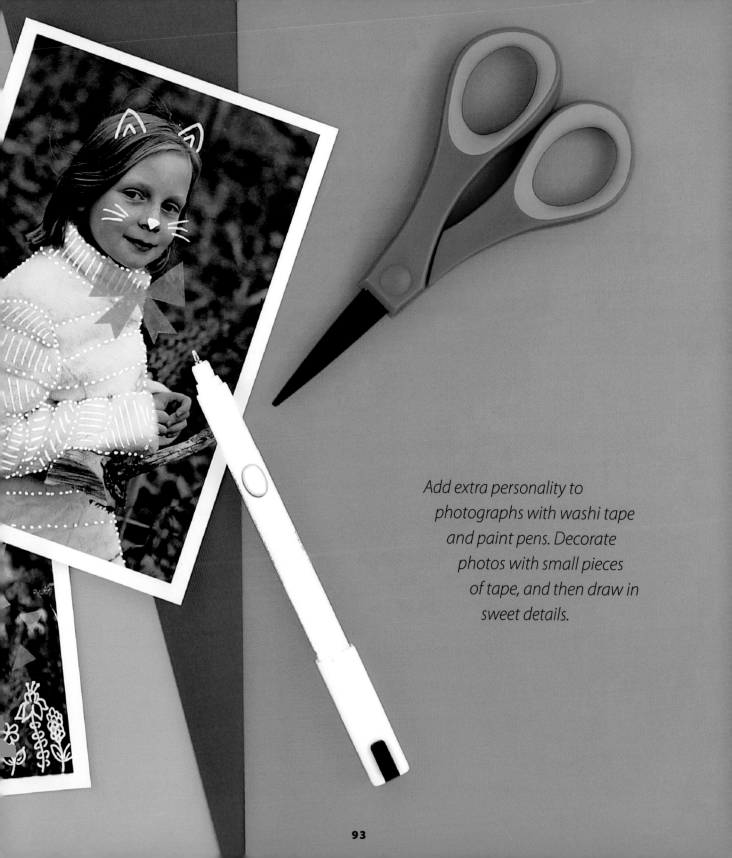

Add extra personality to photographs with washi tape and paint pens. Decorate photos with small pieces of tape, and then draw in sweet details.

PAPERCUT BOUQUETS

Everyone loves a beautiful bouquet of blooms! It's always fun to experiment with new techniques, and I think you'll love creating this simple papercut design—the washi tape is just the icing on the cake! Make it simple and stripy, or show off your washi tape prowess by coloring in the different elements with your favorite colors and patterns.

TOOLS & MATERIALS

- Card stock or heavy-weight paper
- Pencil
- Cutting mat
- Craft knife
- Washi tape

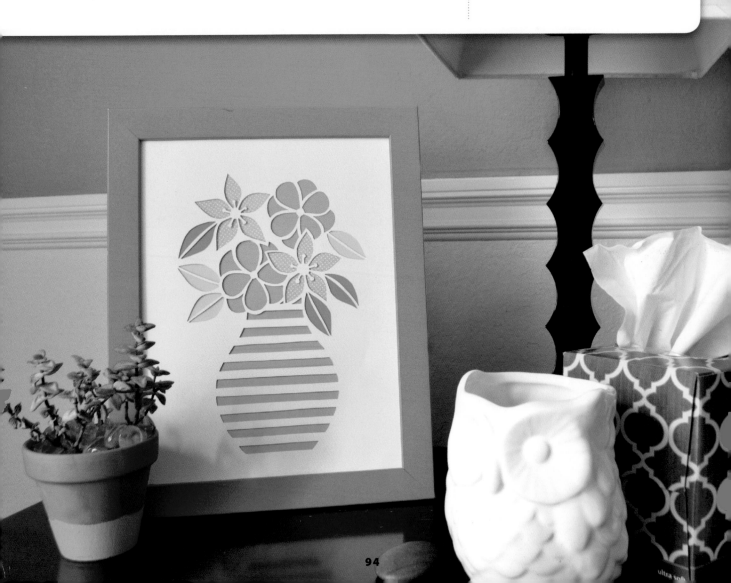

Creating the Papercut

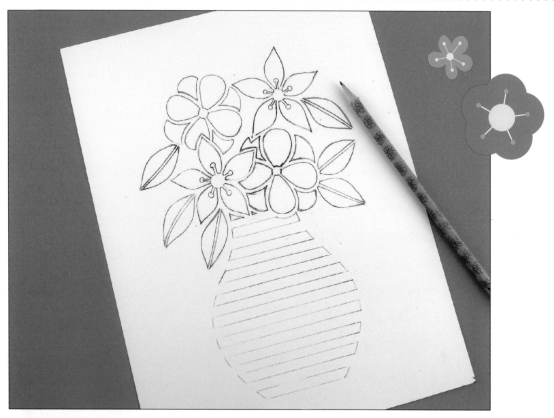

STEP 1

Start by drawing a papercut design onto the back of a piece of card stock. Make sure that the design features connecting elements so that it remains in one piece once you cut it.

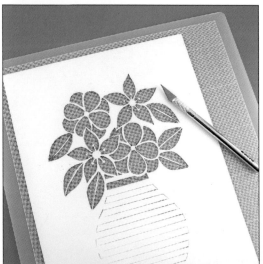

STEP 2

Place the design on a cutting mat, and use a craft knife to carefully cut out each enclosed section of the design. Continue cutting until the entire design is revealed.

Striped Bouquet

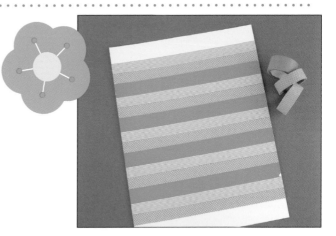

STEP 1

For a simple, striped underlay, apply strips of washi tape to a second piece of paper. Make sure that the long edges of the strips align without gaps or overlaps.

STEP 2

Place the papercut design over the striped washi tape layer.

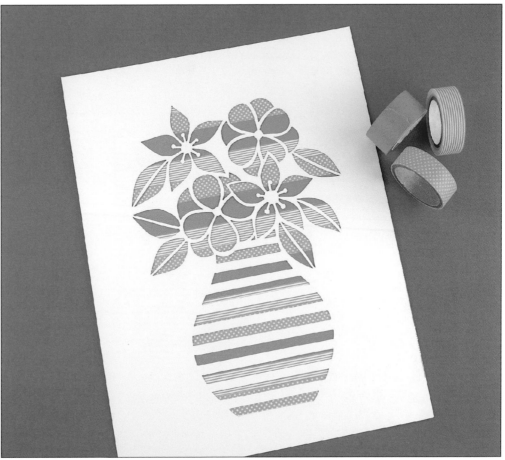

Colorful Bouquet

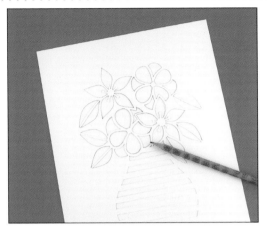

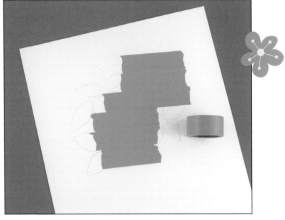

STEP 1

Coloring each segment of the design with tape requires a little more work. Start by placing the papercut design right side up on a second piece of paper. Align all the sides, and use the design as a stencil, lightly tracing it onto the blank paper.

STEP 2

Set aside the papercut design, and work with the tracing. Starting with one color or pattern, apply tape over the desired sections. You may want to erase pencil marks as you go because they might show through the tape.

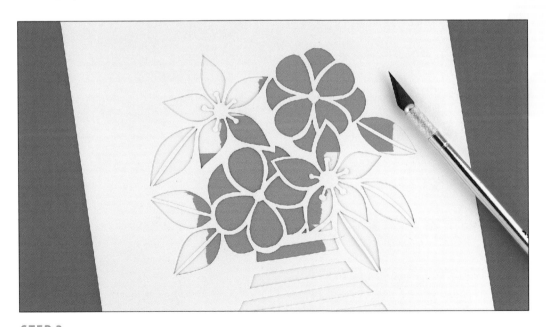

STEP 3

Place the papercut design over the washi tape layer to check alignment. Lightly mark any tape that extends into other sections.

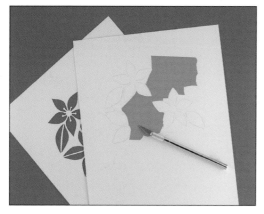

STEP 4
Carefully cut and peel off extra tape. Make sure to use a light touch; you want to cut through the tape without cutting the paper underneath.

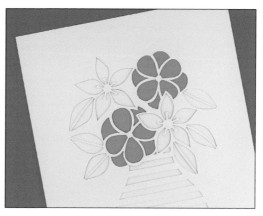

STEP 5
Repeat steps 3 and 4 until all extra tape is removed.

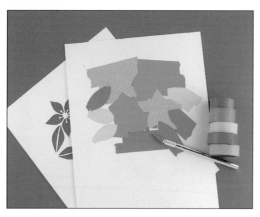

STEP 6
Apply additional colors of tape, trimming tape as before, until the entire design is colored in.

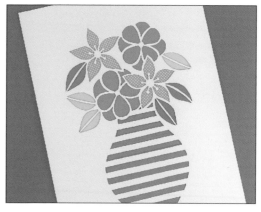

STEP 7
Place the papercut design over the washi tape layer, and admire your finished piece!

SKIP THE TAPE!

Love the idea of adding color to a papercut piece but think fussing with little bits of washi tape seems like too much work? Skip it! Simply layer your finished design over a second piece of card stock in a bright color, and let the beauty of the design shine through.

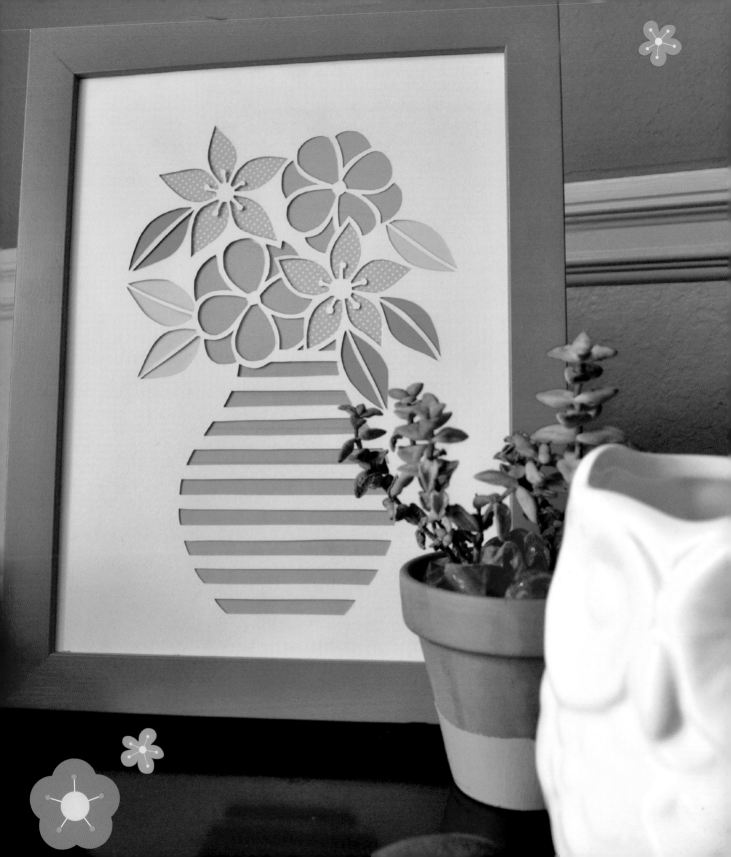

FRINGED
STATEMENT EARRINGS

* * * * * * * * * * * * * * * * * * * *

It's always fun to combine washi tape with unusual materials, especially when the final result is as fabulous as these earrings. Long, lightweight, and perfect for hot summer nights, these fringe-tastic earrings won't give away your secret—that you made them out of tape! I love combining vinyl with tape; it adds structure and a bit of protection while still being lightweight and flexible. The only question that remains is: How many pairs will you make?

TOOLS & MATERIALS

- Washi tape (3 colors)
- Clear vinyl
- Ruler
- Scissors
- Small hole punch
- Earring wires

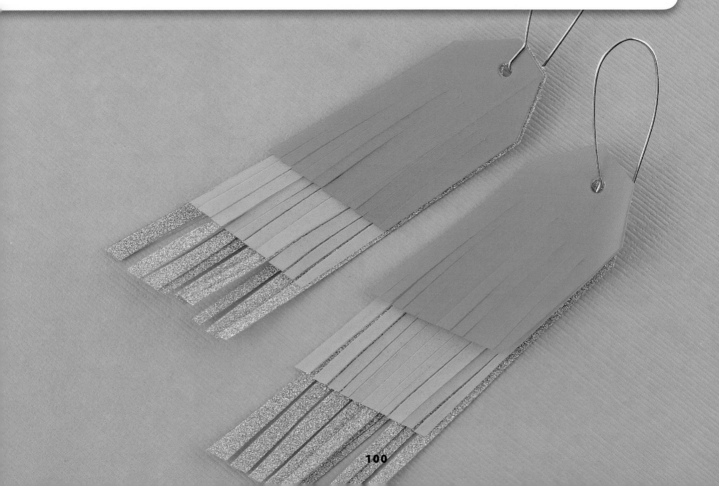

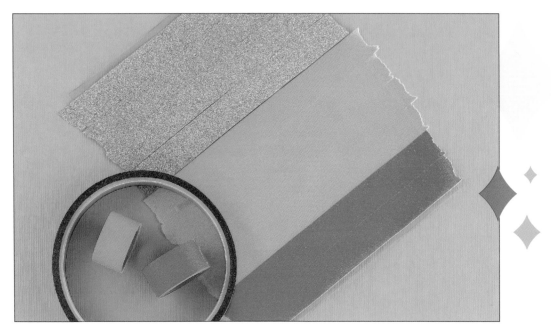

STEP 1

Start by applying strips of tape to a piece of vinyl approximately 4" x 7", aligning the long edges without any gaps or overlaps.

STEP 2

For each pair of earrings, you need six washi tape-covered strips of vinyl. For the bottom layer, cut two 1" x 3½" strips. For the middle layer, cut two 1" x 2½" strips. For the top layer, cut two 1" x 1½" strips.

STEP 3

Lay the three strips on top of each other. Check the width of the earring. If you want a slimmer piece, now is the best time to trim it. Cut the top corners at an angle, leaving a flat top in the middle. Punch a small hole in the center.

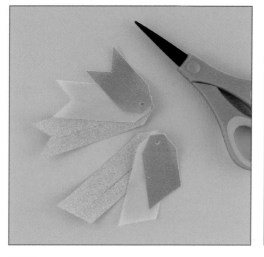

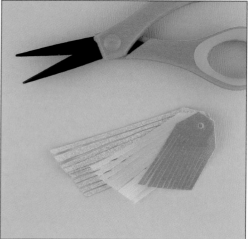

STEP 4

Trim the layers to your desired length and shape. Try angled or ribbon edges for more interest.

STEP 5

Use scissors to fringe the layers with multiple long, parallel cuts. Make sure to leave the top ½" uncut.

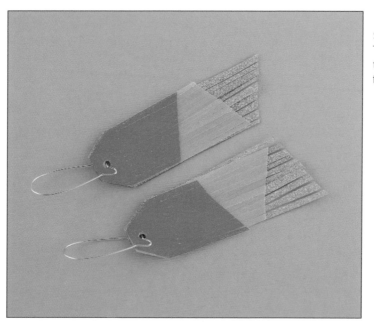

STEP 6

Thread the earring wire through the holes in the three layers to form the earring.

MAKE IT A BUTTON!

Of course, fringy fun is not limited to earrings. I love the look of a washi tape badge, but for more flair, I added some fringed layers of vinyl. So fun! Use this idea to craft special birthday buttons! And there's no reason to stop there. Why not try transforming washi tape-covered shapes into a modern necklace?

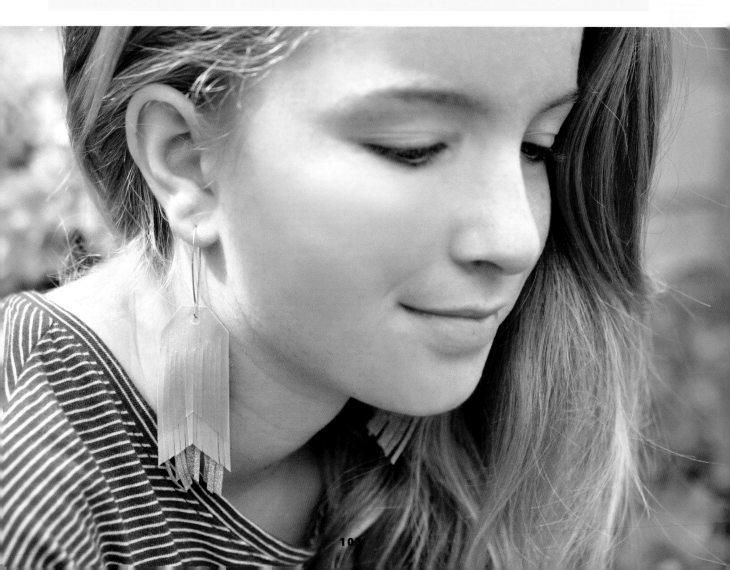

DELICIOUSLY DOTTY ALPHABET MAGNETS

* * * * * * * * * * * * * * * * * * *

While I love classic alphabet magnets, custom sets are definitely more fun—especially when they're dressed in polka dots! I consider this technique a kind of washi-tape decoupage and use it for household and accessory projects all the time. You see, when washi tape makes decoupage this easy, there's no need to stop at magnets! Dress up all sorts of household items in washi tape, apply a layer of Mod Podge to seal, and enjoy your custom creations.

TOOLS & MATERIALS

- Wooden alphabet shapes (approx. 2" to 3")
- Dotted washi tape rolls
- Craft knife
- Mod Podge® (optional)
- Paintbrush (optional)
- Magnetic tape (or magnets) and glue

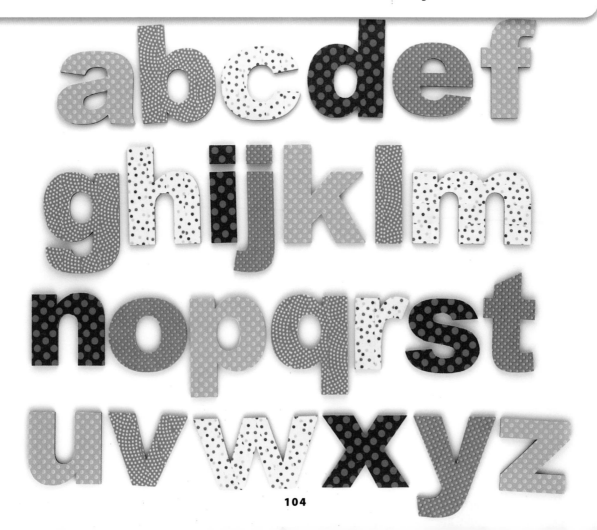

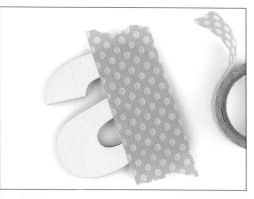

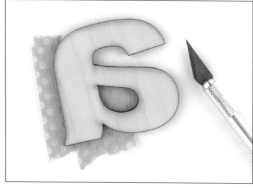

STEP 1

Apply strips of washi tape to the front of the wooden letter. Align patterns where possible, making sure to avoid gaps and overlaps.

STEP 2

Continue adding tape until the entire letter is covered. Then flip it over, and carefully cut away the excess tape from edges and enclosed areas with the craft knife.

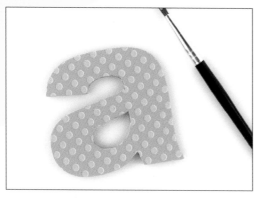

STEP 3

If desired, apply a coat of Mod Podge to the top and sides of the letter to seal.

STEP 4

Let dry completely before applying pieces of magnetic tape to the back. Repeat with the other letters.

TIP

To seal or not to seal? Some tapes lose their stickiness more easily than others. If you're concerned about the tape peeling, or if your magnets will be handled frequently, sealing is a good idea. If you'd like to change the look of the magnets periodically, skip the sealing.

MAKE IT MULTICOLOR

Want more variety on each letter? Mix colorful tape strips, or try a patchwork effect with small pieces.

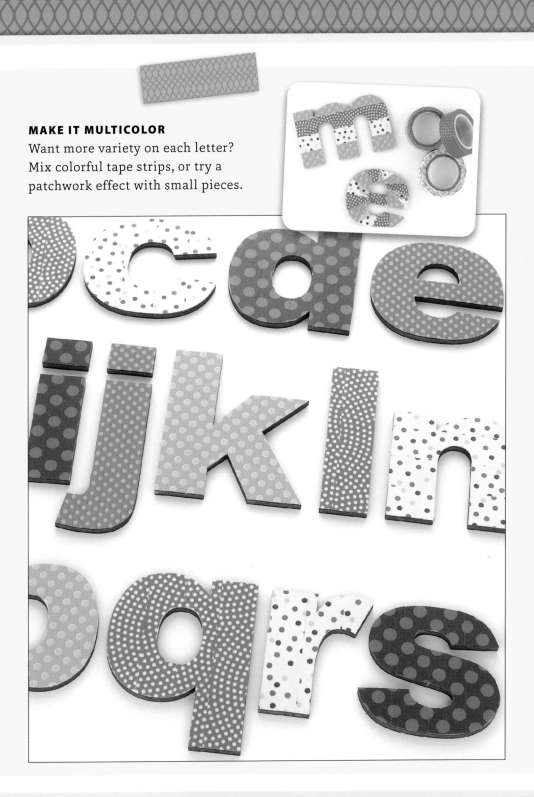

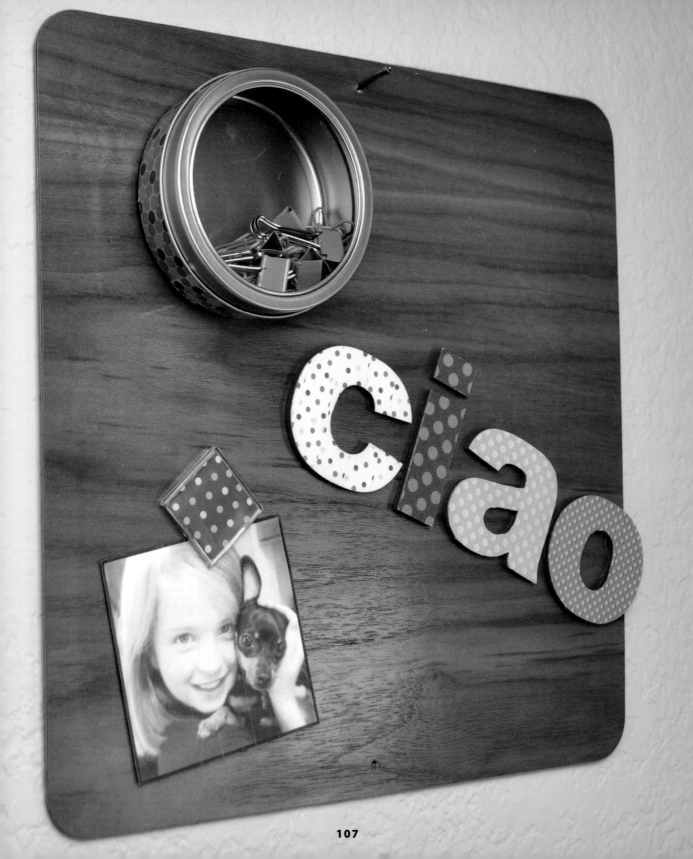

COLOR BLAST COLLAGES

* * * * * * * * * * * * * * * * *

This simple take on the collage technique can be quite striking. Washi tape looks fantastic combined with vintage imagery and colorful card stock. The translucent quality of the tape allows the images to peek through while still delivering bold color. The resulting pieces are something you'll be proud to hang on your gallery wall. The images you choose make the collage. Try looking for interesting illustrated books and magazines in thrift stores.

TOOLS & MATERIALS

- Illustrations, photographs, vintage paper
- Washi tape
- Paper
- Parchment or wax paper
- Scissors and/or a craft knife
- Colorful card stock
- Paper punches (optional)
- Glue

STEP 1

Gather a variety of small illustrations and images that you think are interesting. I find that when working with collage, it helps to collect lots of images and then narrow down the selection to just a few.

STEP 2

Select the images you want to include in your collage. Carefully cut around the edges and inside any enclosed spaces.

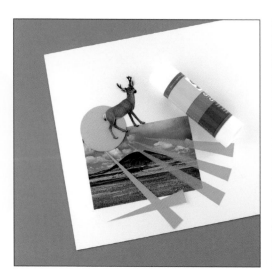

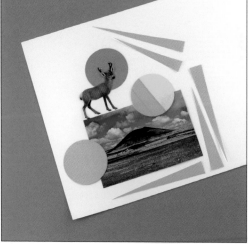

STEP 3

Prepare the graphic elements. Cut or punch out shapes from colorful card stock and washi tape on backing paper. Try different arrangements with your pieces. Once you are satisfied, assemble your collage, using glue to secure paper pieces.

Even if you plan to use simple, straight strips of tape, applying it to backing paper allows you to experiment with different designs before committing to the final version.

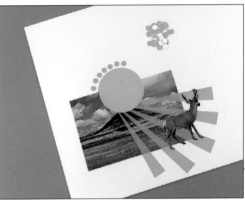

STEP 4

If desired, add small pieces of washi tape or paper to complete your collage. Small, colorful dots have a big impact. Use a standard single hole punch to make dots from washi tape-covered card stock.

5 NON-SCRAPBOOKING WAYS TO USE SCRAPBOOK PAPER

* * * * * * * * * * * * * * *

I don't know about you, but whenever I visit a craft shop, I find myself mesmerized by the wall of scrapbooking paper. There are just so many pretty designs to choose from. But what if, like me, you're not a scrapbooker? No problem! Next time you're confronted with a wall of paper, pick your favorites and get paper-crafty. Here are five fun ways to use scrapbook paper that don't involve any scrapbooking.

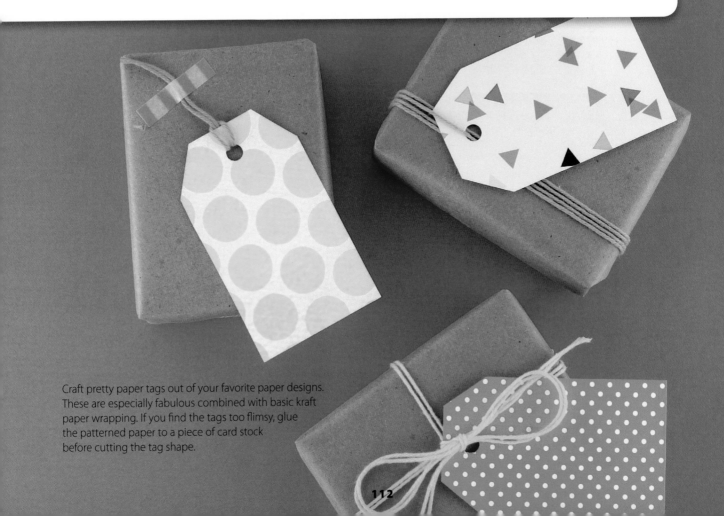

Craft pretty paper tags out of your favorite paper designs. These are especially fabulous combined with basic kraft paper wrapping. If you find the tags too flimsy, glue the patterned paper to a piece of card stock before cutting the tag shape.

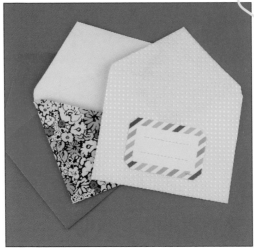

Small gifts look lovely wrapped in scrapbook paper. The patterned papers are a nice weight for wrapping, plus you don't have to buy a whole roll for just one little gift! Tie on some colorful twine or ribbon as a finishing touch.

Elevate your snail mail by creating custom envelopes. To make a template, pick an envelope you like and carefully open the glued edges. Trace the envelope shape onto scrapbook paper. Then cut, fold, and glue to form your custom envelope.

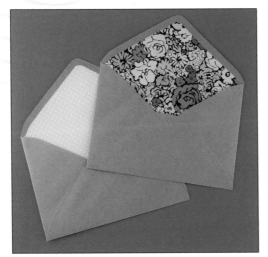

If making your own envelopes feels like too much work, make envelope liners instead. Trace the shape of the envelope with open flap onto scrapbook paper. Cut out the shape, cutting a little bit inside the line. Slide the liner inside the envelope to check the size, and then glue into place.

Make the prettiest everyday cards by gluing patterned scrapbook paper onto blank cards. Add a few strips of washi tape, and you'll have a fancy greeting card without a costly price tag.

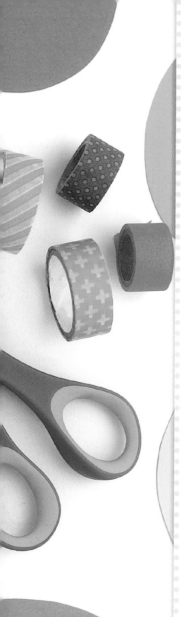

WRITE

✳ ✳ ✳ ✳ ✳

From decorating office supplies to making your own cards, writing with washi tape is a skill you can use for so many things. Learn four different ways to write with washi while creating personalized stationery, packaging, and posters.

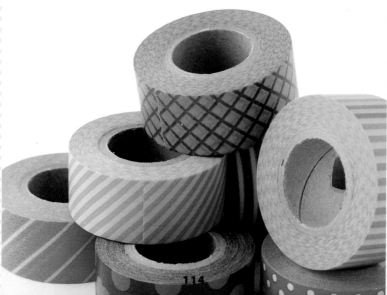

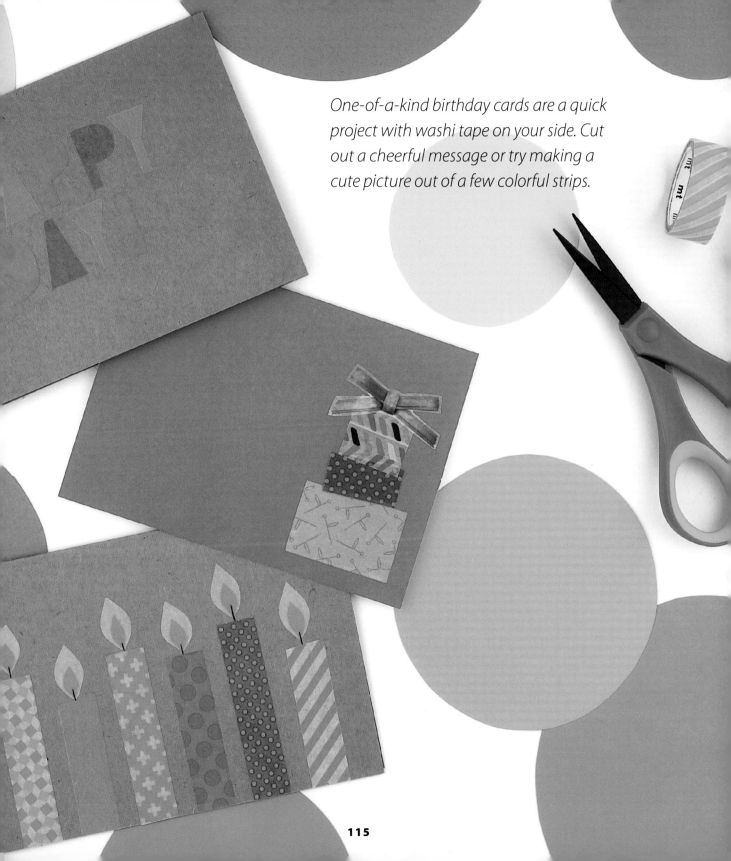

One-of-a-kind birthday cards are a quick project with washi tape on your side. Cut out a cheerful message or try making a cute picture out of a few colorful strips.

SAY ANYTHING NOTEBOOKS

✳ ✳ ✳ ✳ ✳ ✳ ✳ ✳ ✳ ✳ ✳ ✳ ✳ ✳ ✳ ✳

Blank notebooks are way more fun when you personalize them with washi tape. Add some modern flair with easygoing, hand-cut tape text. Since you will be working with small pieces of tape, it's a good idea to skip cutting out the enclosed sections of letters—this adds to the modern-casual feel. Mix and match your favorite colors or stick with a single color. Once you've mastered the art of freehand tape text, you can add washi messages to handmade cards, gifts, and papercrafts.

TOOLS & MATERIALS

- Washi tape
- Wax or parchment paper
- Scissors
- Blank notebook

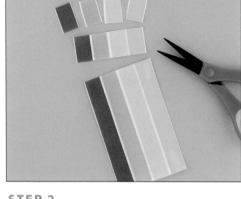

STEP 1
Apply strips of tape to a piece of wax or parchment paper.

STEP 2
Cut the strips into pieces approximately ¾" to 1" long.

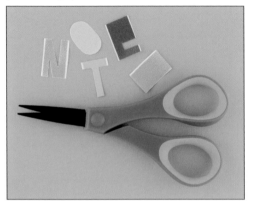

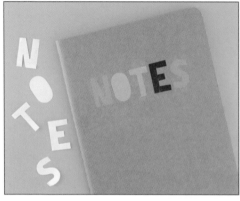

STEP 3
Use scissors to cut out the letters.

STEP 4
Arrange the letters on the front of the notebook to determine the positioning. Then carefully peel off the paper backings and stick the letters to the notebook. Start with the middle letter to help keep the spacing consistent!

SAY ANYTHING SAMPLER

If you'll be doing lots of writing with washi tape, it might be a good idea to create your own alphabet sampler or style guide. It's also great practice! Cut letters from A–Z and attach to a sheet of card stock or the inside of a notebook. Refer to your washi tape sampler when crafting messages.

SAY-IT-WITH-SCRIPT CARDS

* * * * * * * * * * * * * * * * *

One of my favorite tricks is transforming washi tape into fancy cursive stickers. Make it even more personal by creating tape text with your own unique handwriting. I love this technique for crafting one-of-a-kind cards, but it can also be used to make wall art, decorate stationery, or personalize gifts.

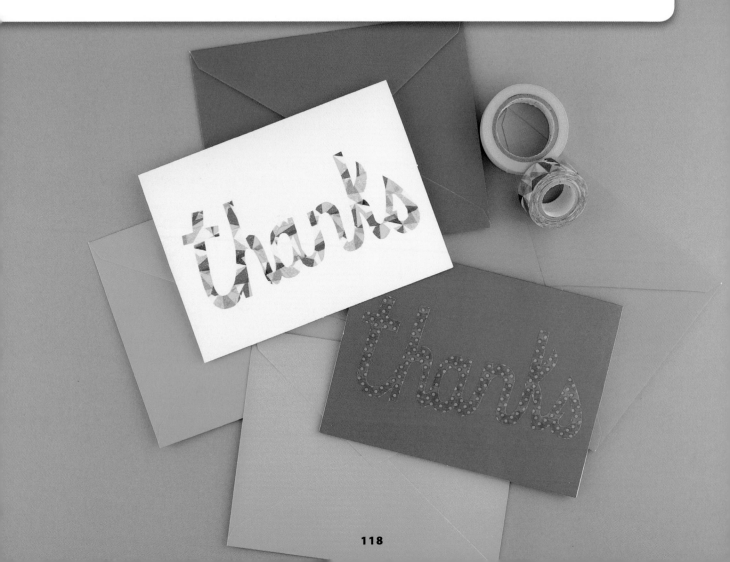

STEP 1

On a blank piece of paper, draw a box the same size as the card you will be using. You can trace the card or use a ruler to measure it. If desired, use a ruler to add guidelines; these will help keep letter heights consistent.

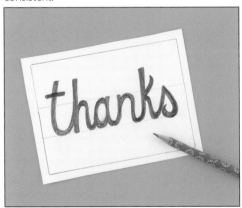

STEP 2

Write the desired text on the paper, making sure each letter connects to the next. Chunky text is easier to work with than fine lettering for this technique.

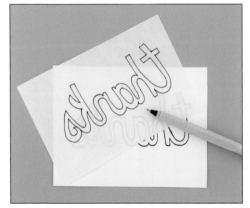

STEP 3

Turn the paper over, and trace the outline of the text onto the back of the paper with a dark marker, creating a mirror image. Then trace the mirrored text onto a piece of wax or parchment paper.

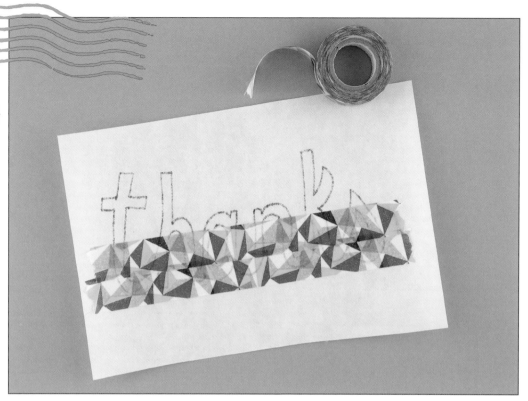

STEP 4

Flip the parchment paper over and cover the text with strips of washi tape. Start at the bottom and work upwards, ensuring that each strip slightly overlaps the one before it.

STEP 5

Once text is completely covered with tape, turn it over and cut along the traced outline. You can use scissors or a craft knife to cut along the outside edges, but you should use a craft knife to carefully cut out any enclosed sections.

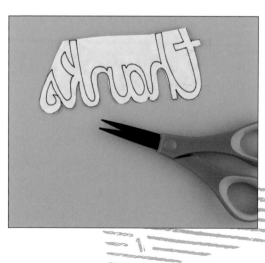

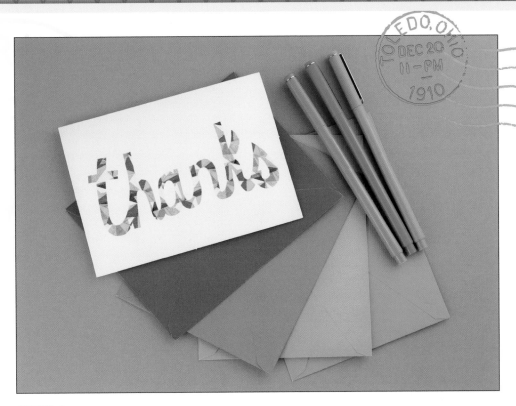

STEP 6

Finally, apply the script sticker to the front of the blank card. Determine the desired position, and then slowly and carefully remove the paper backing and apply. I find it easiest to apply one letter at a time, tearing off small pieces of backing paper as I go.

SKIP SOME STEPS

Don't love your handwriting or need a speedier solution? Create your own custom words and phrases using your favorite font. Type the text, print out a mirror copy, and start from step 4.

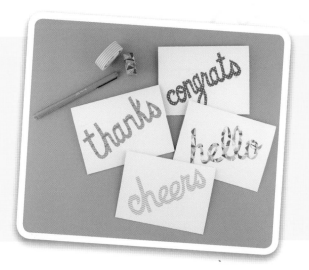

MINI MOTIVATIONAL POSTERS

✶ ✶ ✶ ✶ ✶ ✶ ✶ ✶ ✶ ✶ ✶ ✶ ✶ ✶

Standard motivational posters can be a bit cheesy (and BIG!), so why not make your own? Gorgeous photos and simple washi tape text combine into striking prints that are right at home on your walls. For images, try searching in vintage travel books or magazines.

TOOLS & MATERIALS

- Old magazines or books
- Backing paper
- Marker
- Washi tape
- Scissors
- Craft knife

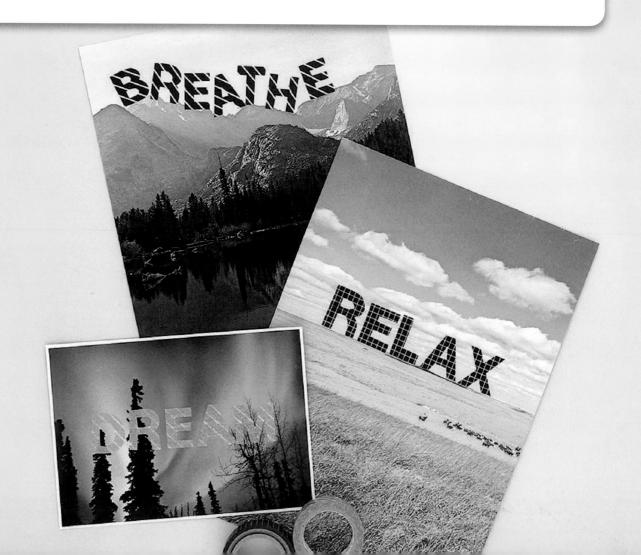

STEP 1

Find images you love, and carefully remove them from books or magazines at the binding. Try scoring with a craft knife first to prevent tears.

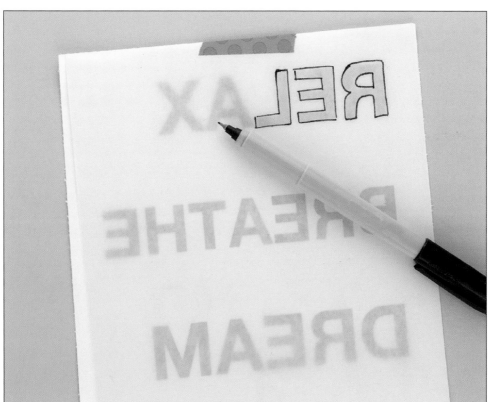

STEP 2

Select some motivational words, and type them on a computer. Then print a mirror copy, and trace the outline of the letters on the backside of your backing paper.

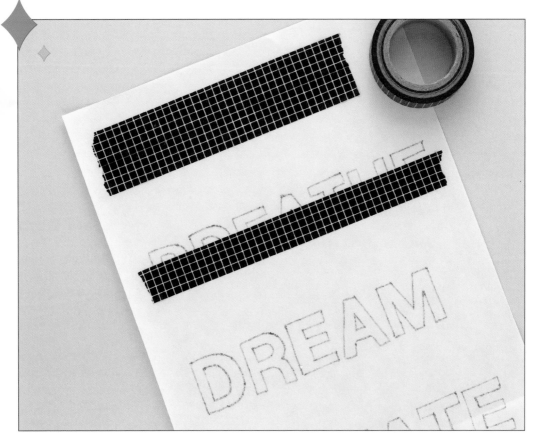

STEP 3

Cover the text with washi tape. Apply one long strip along the bottom edge of the text, with a second strip that slightly overlaps the first. Match up patterns where possible.

STEP 4

Carefully cut out the letters. Scissors work well for exterior edges, but you will likely need a craft knife for cutting out enclosed sections of letters.

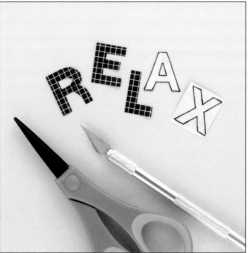

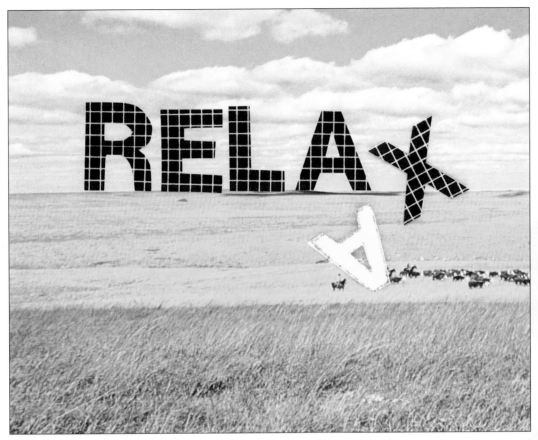

STEP 5

Peel the backing paper off the letters, and stick them to the image. You can apply text in a straight line across the center of the picture or allow it to follow natural lines in the image.

ARTIST'S TIP

Always arrange your letters on the image and play with layout and spacing before removing the backing paper. To achieve even spacing, I find it helps to apply the center letter first and work outward.

QUICK & QUIRKY PAPER BAGS

* * * * * * * * * * * * * * * * *

This project is a play on the classic brown lunch bag. Reusable lunch bags may be the standard nowadays (and for good reason), but that's no reason not to have a little fun with washi tape and brown paper bags. Write a sweet or quirky note on the outside of the bag with slim washi tape letters. Slim washi tape makes a great addition to your tape collection—it's especially fabulous for casual lettering and sleek stripes.

TOOLS & MATERIALS
- Washi tape
- Scissors
- Brown paper bags

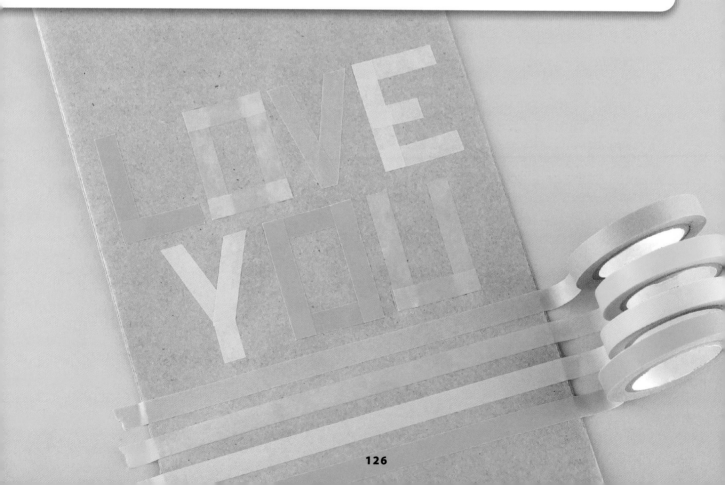

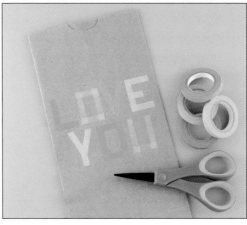

STEP 1
Build your first letterform, overlapping slim strips of tape. Start your letters approximately 3½" – 4" from the top edge of the bag.

STEP 2
Continue adding letters to spell out the message. If desired, alternate colors or patterns. Try to keep the text centered and evenly spaced. I find it helpful to place the centermost letter first and build outward.

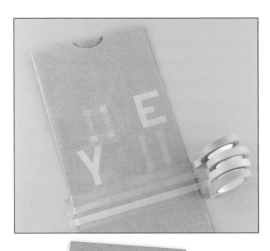

STEP 3
If desired, embellish your bag with decorative tape elements like stripes, dots, or torn strips. Fill the bag, and fold the top edge over to seal with washi tape.

ARTIST'S TIP
Want to write a message but don't have time to fuss with sizing and alignment? Use torn pieces of tape instead of cut strips to form letters, and craft your message in no time! When writing with tape in this manner, I like to apply the tape to the surface, and then tear. This ensures more accurate strip lengths.

ABOUT THE
AUTHOR

* * * * * * * * *

Marisa Edghill is a Canadian craft designer, writer, and paper artist. Known for her work with washi tape and kirigami paper cutting, Marisa delights in transforming ordinary materials into something beautiful. She shares art projects and plenty of crafty inspiration on her website, Omiyageblogs.ca. Marisa is the author of *Washi Style* and is co-author of *Pinterest Perfect* and *Mandala for the Inspired Artist*.

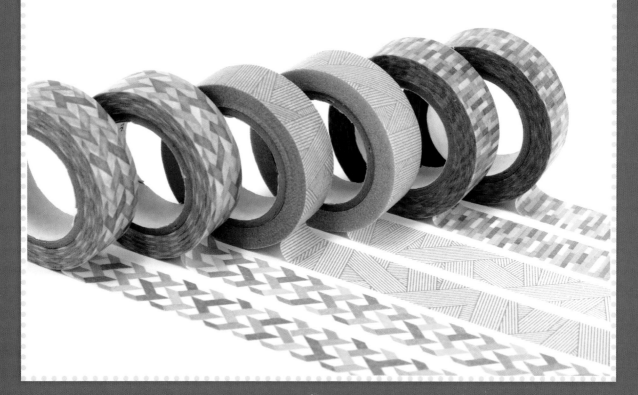